MODERNA MUSEET
MODERN MUSEUM

MODERNA MUSEET
MODERN MUSEUM

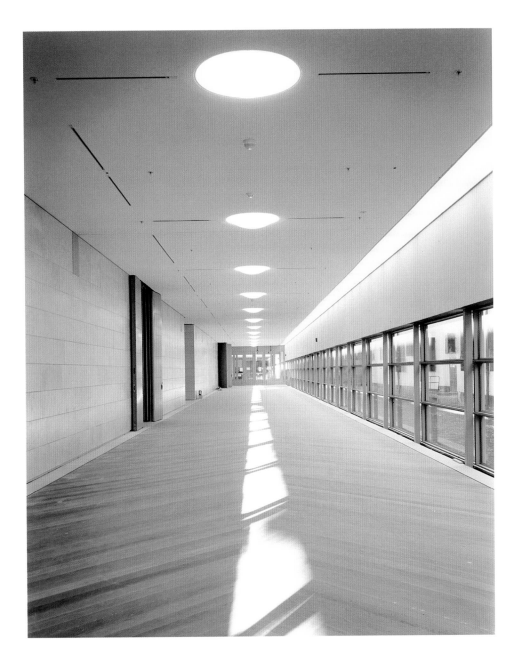

SCALA BOOKS

Moderna Museet - Modern Museum

Moderna Museet Stockholm
Copyright © 1998 Statens Konstmuseer, unless otherwise stated

First published in 1998 by Scala Books, an imprint of
Philip Wilson Publishers Limited
143-149 Great Portland Street, London W1N 5FB

Distributed in the USA and Canada by
Antique Collectors' Club
Market Street Industrial Park
Wappingers' Falls, NY 12590 USA

Exhibition catalogue no. 267
ISBN 1 85759 178 X

Photographs: Statens Konstmuseer, unless otherwise stated. P.18: Hans Hammarskiöld; P 17: Nils Göran-Hökbv; P. 88: Ingeborg and Dr Wolfgang Henze-Ketterer, Bern; P. 130: Hans Namuth, 1946; P. 150 John R. van Rolleghem; P. 157 The Andy Warhol Museum, Pittsburgh; Founding Collection, Contribution The Andy Warhol Foundation for the Visual Arts, Inc.

Authors: David Elliott, Teresa Hahr, Carl-Fredrik Hårleman, Henrik Orrje, Leif Wigh, Nina Öhman
Design: Tomato, London

Front cover:
Le cerveau de l'enfant (The Brain of a Child),
Giorgio de Chirico, 1914

Back cover, from left to right:
Smabrukaparet Albert och Tea Johansson
(The Farmers Albert and Tea Johansson)
Sune Jonsson, c. 1955

Cage
Alberto Giacometti, 1930-31

La Source (The Spring)
Pablo Picasso, 1921

Moderna Museet is sponsored by:
NCC, Pharmacia & Upjohn AB, Posten AB,
SAS and Svenska Dagbladet

Printed and bound by Snoeck-Ducaju & Zoon, NV, Ghent, Belgium

Contents

Sponge, Mirror and Knife David Elliott

I am beginning my first description of the new Moderna Museet and its policy with an image of a ficititious still life: three objects – a sponge, a mirror and a knife – set out on a table. Together they express the different functions of the Museum. The genre of still life is traditionally thought to be quiet and reflective and there are many examples of this in the new Museum. Yet as many modern artists, from Boccioni and Picasso to Cindy Sherman and Damien Hirst have shown, it may also be dynamic, unsettling.

When I moved to Stockholm in 1996, not only was I the first non-Swede to be offered the Directorship of Moderna Museet but I also arrived at a critical time in its development. In 1998 the Museum will be 40 years old. It has a distinguished history and a collection that, as you can see from these pages, is of the highest quality and could never be built up today. It also occupies a magnificent location. As a beauty spot Stockholm is one of Europe's best kept secrets, and Moderna Museet, by the sea on the magical island of Skeppsholmen, is one of its jewels. The view across the harbour is one of the best of any Museum in the world.

Like a green lung, the small island pulsates in the body of the city. The museum shares it with the Architecture and East Asian Art Museums and the Royal Academy for Visual Art as well as with a number of other arts organisations. In addition there are several artworks placed in the landscape that definitively announce the arrival of the visitor in another territory – an art zone – where the utopian *Paradise* of Niki de Saint Phalle and Jean Tinguely jostles with Picasso's *Déjeuner sur l'herbe*, where Erik Dietmann's wry *Monument to the Last Cigarette* coughs and wheezes against the structural rigour of Ulrich Rückriem's black granite blocks.

But even in Paradise things do not always run smoothly. In the 1970s and '80s, despite of a number of improvements to its original premises, the Museum needed much more space and better conditions in which to show its collection. The former naval drill hall that it first occupied could no longer meet the stringent requirements demanded by a modern museum. Only a small fraction of the collection could be shown and much of this had to be stored to make way for large temporary exhibitions. The vast collection of the Photographic Museum, which in 1973 had been incorporated into Moderna, had added to the problem.

6

Additionally, there were no permanent facilities for the showing of the museum's pioneering collection of artists' film and video.

There was also a growing demand and expectation from both the public and artists to see more of the collections, to be stimulated by different and more varied exhibitions and to participate increasingly in the museum's active public access and education programmes. Moderna was too big for its skin; something had to happen.

In 1990 the Swedish Government grasped the nettle. A competition was announced for designs for a new Moderna Museet. Over 211 proposals were received and five internationally renowned architects, including Tadao Ando from Japan, Frank Gehry from the USA, Kristian Gullichsen from Finland, Jørn Utzon from Denmark and Rafael Moneo from Spain were asked to participate. The brief was to respond to the unique atmosphere and skyline of the island while constructing a modern building with some 20,000 square metres of floor space.

The following year Rafael Moneo was announced as the successful architect; his plan respected the existing environment while at the same time making a strong architectural statement. He accomplished this seemingly impossible task by blasting the space for the new museum out of the living rock of the island. The result is that from the city and the sea the three-storey modernist building rises from the shore, its characteristic pyramid-shaped roof line echoing the pre-industrial forms of boat-building cranes. But when approaching on foot from the island hardly anything can be seen; from this side the Museum appears to be only one storey high and is largely hidden behind an old naval prison and the former rope making factory now occupied by the East Asian Art Museum.

At night Moderna's illuminated roof lanterns are a landmark. Its facade is embellished by the long strip windows of the restaurant and café; a few smaller, barred windows look out from education workshops, conservation studios and offices; otherwise, like in an ancient Spanish Alcazar, the wall surface is uninterrupted, almost fortified against the sea. Inside the Museum, orientated around a linking promenade, a series of discrete, high-walled galleries of different sizes open out, one space leading on to the next. Their floor areas are based on a six-metre grid, which is a recurring unit of measurement throughout the museum and which is multiplied to provide the larger spaces. Both naturally and artificially lit, their large volumes give them a spiritual, almost ecclesiastical atmosphere; their unexpected conglomeration and massing echoes the informal, organic architecture of the Arabian souk.

The new Museum opened in February 1998 – the year in which Stockholm became the European Cultural Capital. Over 30,000 20th century prints and drawings were transferred from the National Museum and a new area of collecting was opened up.

But now that it is safely housed in its new premises, what policy will the new Museum adopt and what direction will it take in its collecting? The initial impulse will be to continue the first principles set out by Pontus Hultén, Director of Moderna Museet in the late 1950s and throughout the 1960s, when he worked with living artists and purchased important works while they were still affordable. In this way Robert Rauschenberg's *Monogram 1955-59* entered the collection. Similarly, it was only by inviting Marcel Duchamp to come to Stockholm – at a time when the rest of the art world was not so interested in his work – that Ulf Linde had his first reconstruction of *The Large Glass* signed by the artist (a second, more accurate version has since been made, which is illustrated here). The same dynamism and contact with the present must be re-established to build a great collection for the future. But the historical collection cannot be neglected and the Museum will continue to be dependent on the generosity of its patrons whether by providing funds for purchases or by donating works themselves.

To be successful, museums must reflect the spirit of their times and their collections. Willem Sandberg, the Director of the Stedelijk Museum in Amsterdam during the 1950s, had been a member of the Resistance during the War and felt that the Museum should have a high moral and ethical purpose related to the artistic ideals of freedom and spiritual transcendence. He was an ascetic man who greatly valued the work of both Piet Mondrian and Kasimir Malevich, which was strongly represented in the Museum's collection. This was an important model for Pontus Hultén who, younger than Sandberg, reflected the atmosphere of a different situation and time in his thinking about Moderna Museet. Each generation has its own art and attitudes. Assuming the director-ship at the dawn of the 1960s, Hultén radiated an optimism – even a utopianism – that fuelled the Museum's early years. It was not by chance that the arcadias of Picasso, Niki de Saint Phalle and Jean Tinguely graced its approaches. But these were not the *fêtes champêtres* of an elitist and dying *ancien régime* but the picnics of the social democracy of the present and future. The demotic language of Pop Art, which featured in the collection and exhibitions at this time, also seemed to echo this idea. The new art was social, material and dynamic rather than transcendent. Barriers had been broken. Echoing the slogans of the Russian Revolution: art was for and by the people.

In the years that have passed since that time many worms have tried to eat through this particular bud. Wars, famine, terrorism, genocide, oil crises, the failure of the ideologies of Left and Right, the resurgence of nationalism ... the list of ruptures and pestilences could go on for ever. Modern art is now no longer purely a product of the First World but can be, and is, made anywhere. But although it is related to lived experience and influenced by it, it is not life itself but a comment on it. In this context a classical aphorism rings true: *ars longa, vita brevis* – art continues, life is short. If we are less innocent and more cynical now than we were in the early 1960s, it is not because atrocities did not previously take place, but because the growing immediacy of news, information technology and other mass media have brought these events into the home almost at the same time as they have happened. The comforting insulation of time and distance has evaporated. The whole world lives in the same real time.

As much of the new work in the collection indicates, and as is evident from the inaugural exhibition – *Wounds: between democracy and redemption in contemporary art* – artists have anticipated and responded to these changes. The institutions of art have also become more mature, better resourced, and accordingly, more complex.

To operate effectively in the present and future, Moderna Museet will have to be able to contemplate and interpret the allegory of the still life with which this essay began. First it should be like a sponge. In its duty of research it must suck up as much information as possible about the visual culture of our time and century – this includes the consideration, and if necessary, the rejection, of new critical views on past and present. The art of the whole world must be considered. The fruits of this work should be made publicly available. Secondly it should be like a mirror, reflecting the range of work that is being made. A mirror cannot invent something that is not there and neither should the museum. The Museum must serve art and be driven by it. Lastly, the Museum must be like a knife – cutting through falseness, pretension and time-wasting to the core of what is valuable. In this respect, those who work for it must use their faculties of discrimination to establish what they feel is good. Since the 18th century Enlightenment, Modern art has been a model of freedom. This moral aspect, this ideal of artistic autonomy – at times moth-eaten and discredited, at other times triumphant – has survived to the present day; that is why modern art is threatened whenever a totalitarian government comes into power. Quality in modern art has as much to do with these human values as it has with originality and skill; the intelligent combination of these elements is what we mean by quality.

If, and only if, the Museum can satisfy these requirements will its audience, as wide and as diverse as possible, be satisfied. Modern art has not, cannot and will not be led by demand. Such an idea is impossible because it is in a constant state of development and change. The task of the museum of modern art is to mediate between art and a wider public. It has to find the right spaces, the right lighting, the right languages, the right tones of voice and, on occasion, the right time to remain silent, to enable art to speak for itself. By definition, art can never be paraphrased or translated into another language – that is why it is what it is. But the paths that lead to it can be illuminated or made easier – and as a result more enjoyable.

This is the task of the modern museum.

Stockholm, October 1997

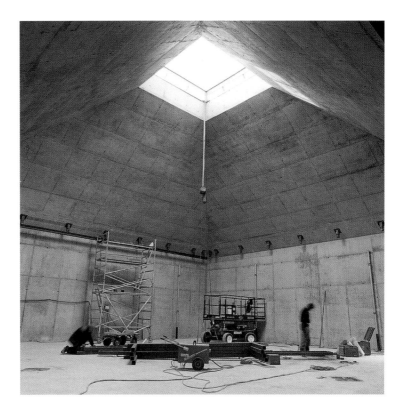

The interior of the new Moderna Museet
during construction 1996-97

Moderna Museet – Forty Years

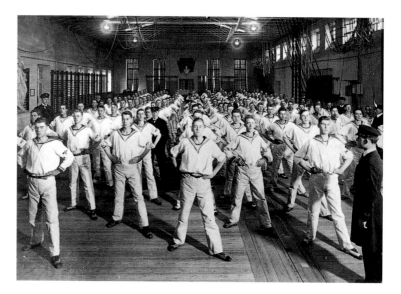

The Swedish Navy's Exercise
House at Skeppsholmen

1953

The painter Otte Sköld, at the time Director of
the Nationalmuseum (The Swedish National Art
Collections from the Middle Ages to the Present
Day), successfully persuaded the government to
create a museum specifically for 20th century art.
A suitable building already existed – a disused
naval drill hall on an island in the middle of
Stockholm. The government empowered the
Nationalmuseum to separate the 20th century
art from the main collection. Work on converting
the premises began in 1956.

At the same time an association of 'Friends
of Moderna Museet' was formed and their
collection of 150 works of art was donated via
the Nationalmuseum to 'a future museum of
modern art'.

1956

Picasso's *Guernica* was shown in the partly
converted drill hall at Skeppsholmen.

1958

Moderna Museet was formally opened on 9 May,
showing Swedish and international art from
the beginning of the century to the present.
A programme of exhibitions was started and
a committee was formed for purchasing works
by contemporary Swedish artists. The committee
consisted of a painter and a sculptor as well as
the Director of the museum.

In the autumn Otte Sköld died and Pontus Hultén
was appointed director.

Inauguration of Moderna Museet
9 May, 1958, in the former
House of Exercise

1959-62

Pontus Hultén writes:

During these years we had been working on the preparations for our first major thematic exhibition Rörelse i konsten *(Movement in Art), which was to open in May 1961. In fact the preparations had stretched over an even longer period. In 1954 I put together at the Galerie Denise René in Paris an exhibition entitled* Le Mouvement *and a year later, in Agnes Widlund's gallery Samlaren at Birger Jarlsgatan in Stockholm, Jean Tinguely's meta-mechanical sculptures. In connection with this, a special supplement was published by the magazine* Kasark: 'Proximate Freedom or Movement in Art' *about kinetic art in the 20th century.*

Seeing the new art in New York was a profound experience for me and it seemed that this would

be a good theme for an exhibition devoted to the violent dynamism of the period. Later we mounted other exhibitions that illustrated even more clearly what was actually happening in New York. To this period belong the exhibitions 4 amerikanare *(4 Americans) (1962) and* Amerikansk Pop konst. 106 former av kärlek och förtvivlan. *(American Pop Art. 106 Forms of Love and Despair) (1964).*

The exhibition Rörelse i konsten, *as the museum's own 'product' for an unprepared Swedish public, unleashed a great shock. Here I had come to an agreement with Willem Sandberg of the Stedelijk Museum in Amsterdam, with whom I had long been acquainted and who was then director of what was probably the best museum of modern art in the world, that he would show the*

Marcel Duchamp and Ulf Linde consider *The Large Glass*,
1961, which Linde has reconstructed.

*exhibition first. Then, with minor additions, it
would come to Stockholm. This was naturally
conditional on my retaining control of the content
and production of the exhibition. This led to our
having to print a Dutch edition of the catalogue
in Stockholm but with the help of Hugo Gebers
everything proved satisfactory. The exhibition,
known in the Netherlands as* Bewogen Beweging,
*succeeded in shocking the hardened Amsterdam
public but ended as a great success and Sandberg
was very satisfied with the arrangement.*

Rörelse i konsten *was a complicated and wide-
ranging exhibition; a highly ambitious venture.
More than 80 artists from 20 countries
participated, several of them having produced
work especially for the exhibition. In all, there
were 233 works, from Futurist and Cubist
paintings of the early 20th century to works built
on site specially for the exhibition like, those by
Rauschenberg, Tinguely, Kaprow, Calder and*

*Spoerri who had actively participated in the
preparations. Ulf Linde had made a copy of
Duchamp's original* Large Glass, *now in
Philadelphia, and the artist had come to
Stockholm to work with him. Besides the
historical development, the exhibition included
every imaginable type of object and manifestation:
sculptures outside the museum and at other sites
in Stockholm, films and screenings, light shows,
happenings and concerts; everything that a
dynamic conception of art and life could produce.
The exhibition was one of extraordinary richness
and displayed the greatest optimism at the
beginning of a decade that began so optimistically.
(From* Five fragments from the history of
Moderna Museet, *Moderna Museet Stockholm,
Bonn 1996)*

The new decade brought great success to the
new museum. Concerts, poetry readings and
happenings were arranged in the galleries among
the works on show (for there was no auditorium).
Numerous film series were shown. Special guide-
lectures for children drew a very young audience.

In the spring of 1962, four Americans – Jasper
Johns, Alfred Leslie, Robert Rauschenberg and
Richard Stankiewicz – were invited to exhibit.
Several important works by the young Americans
were acquired for the collections, including
Rauschenberg's *Monogram* (1955-59).

1963-64
Nordic and Swedish art were well represented
in the collections but there were many distressing
gaps in the international collection.

On the initiative of the Friends of Moderna
Museet, an *Önskemuseet* (*A Museum of our
Desires*) was arranged in the winter of 1963-64.
Works that the museum would have liked to
acquire were loaned both from private collectors
and art dealers. Gerard Bonnier, chairman of

the Friends, described it in this way: 'we showed what we would have had if the funds had been available, if we had been out in time, if we had had the opportunity – in short, if "if" had not existed.' The exhibition took as its motto a quotation from Jules Laforgue: 'How beautiful they are, the trains that one misses.'

And then the miracle happened: the government gave the museum a special grant of 5 million Swedish krona, which meant that a number of the borrowed works could stay. These included a collage by Picasso from 1912-13, a sculpture by Giacometti, a work by Dubuffet, de Chirico's *The Child's Brain* (1914), purchased from André Breton along with a large painting by Miró …

Ulf Linde, writer, and critic comments:
I was not myself responsible for the purchases – which somewhat annoyed me because the exhibition was my idea – but Pontus Hultén and Gerard Bonnier nevertheless consulted me about each purchase; I had my say. We immediately agreed that we should not concentrate on representative masterpieces from the artists' 'mature' periods but that we should look for works displaying a special spark, in which a new idea had come to be expressed – in short, where there was a sense of adventure. And I think we succeeded. The Tate Gallery, London, the Kunstmuseum in Basel, the Sammlung Nordrhein-Westfalen are undeniably richer in 'important' works but if one wishes to gain an understanding of this century's creative fervour in art, of the inspired moments, the euphoria and joy, then Moderna Museet is superior. (From the introduction to the catalogue of Moderna Museet's collections, 1976)

1964
The major spring exhibition of 1964 introduced the Swedish public to American Pop Art and was followed by a retrospective exhibition of the works of Sigrid Hjertén, one of the young Swedish artists who attended Matisse's school in Paris before the First World War. The museum's exhibitions have alternated in like fashion between Swedish and foreign, younger and older, group shows and large one-person exhibitions and so on. In the autumn the famous *5 New York Evenings* took place. John Cage, Merce Cunningham, David Tudor and many others including a cow, invaded one of the large galleries for a week in September. The Swedish artist Per-Olof Ultvedt also took part. The year concluded with an exhibition of Léger.

1965
During the year, Rolf de Maré, founder of The Swedish Ballet in Paris in the 1920s, had allowed the museum to show his planned bequest, which included works by Picasso, Braque, Brancusi and Léger. He died in 1966 and his generous donation greatly enriched the museum's collections.

On the occasion of Francis Bacon's retrospective exhibition, his painting *Portrait of Lucian Freud and Frank Auerbach* (1964) was acquired.

1966
The year started with the large exhibition *Inner and Outer Space*. Much attention was devoted to three artists – Kasimir Malevich, Naum Gabo and Yves Klein; the other '35 artists who have explored the image of space' included Josef Albers, the Swedes Eddie Figge and Olle Baertling, as well as Donald Judd, Piero Manzoni, Barnett Newman and Frank Stella.

A Dada exhibition was also organised, which drew on the museum's considerable collection of replicas of Duchamp's readymades as well as on important works by Kurt Schwitters and a painting by Francis Picabia.

During the summer *HON (SHE)* proved to be a

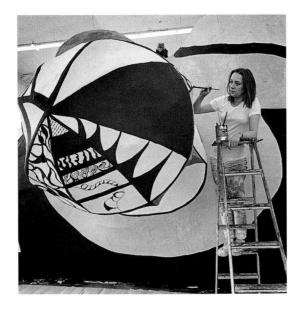

SHE, 1966. Niki de Saint Phalle is finishing
the painting of the head

milestone in the museum's development. The press
release read:
HON *is a cathedral in the form of a giant female,
built by Niki de Saint Phalle, Jean Tinguely and
Per-Olof Ultvedt. SHE is 82 feet long, 20 feet
high, and 30 feet wide. Her weight is 6 tons.
SHE occupies almost the whole entry hall of the
museum. Since the opening, on June 3rd, more
than 70,000 visitors have seen her. SHE will be
on show until late August.*

*When de Saint Phalle, Tinguely and Ultvedt met
in Stockholm at the end of April, they did not
have any precise idea about what they would
build. Several plans were suggested, but all were
rejected. After a week of discussions, however,
the artists had the idea of creating a giant woman,
of much bigger scale than the 'Nanas' that de*

*Saint Phalle had made in 1965. SHE would have a
living interior, animated by different kinetic
machines by Tinguely and Ultvedt.*

*Niki de Saint Phalle made a small-scale model
and the construction began, 'in the spirit of the
old cathedral builders', as Tinguely said. A group
of five young people helped the three artists
working all night and all day for over 40
consecutive days. Her skeleton, constructed with
big steel tubes, was covered with wire-netting,
on which glue-impregnated linen was fastened
and finally painted in bright colours. On 3 June
SHE was finished.*

*The visitor could walk inside this sculpture,
encountering in the entrance a pond with
goldfishes and a large mill-wheel. In the stomach
sat a man watching TV (a work by Ultvedt).
Another sculpture, also by Ultvedt, represented
The Broken Clavicle. The visitor could take a
drink in the bar, crush the bottle in Tinguely's
'machine-to-smash-bottles', buy a ticket from
the lottery automaton or look at the fabulous
view over the whole landscape of SHE, from
the space restaurant in her top. In her left leg
was a switchback and an exhibition of fake
pictures. In a special cinema, Garbo's first movie
Luffar-Petter from 1922 was on show. A bench
for lovers offered privacy. 'Radio Stockholm'
sent messages.*

While the remains of *SHE* were still littering
the gallery Claes Oldenburg arrived to prepare
his large one-man exhibition that autumn.
During his visit to Stockholm he made proposals
for different monuments including one on
Skeppsholmen, the island where the museum
is situated, for which he proposed a giant
door-handle. For a city square he suggested
an equally gigantic wing-nut. Neither idea has
yet been put into effect, although Oldenburg
has recently made preliminary designs for a
new project in the sea just off Skeppsholmen.

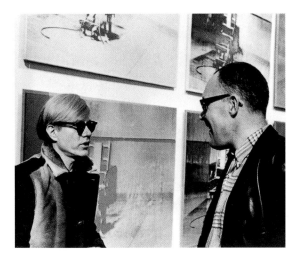

Andy Warhol and Pontus Hultén in front
of Warhol's *Electric Chair*, 1968

1967
Exhibitions of Emil Nolde, Wifredo Lam, Lucio
Fontana, John Heartfield, René Magritte, Raoul
Hausmann, Meret Oppenheim and of the Swedish
artist Bror Hjorth took place.

With Marcel Duchamp as an intermediary, the
museum succeeded in purchasing Salvador Dalí's
masterpiece *The Enigma of William Tell* (1933).

1968
Like almost all the contemporary artists who have
exhibited at Moderna Museet, Andy Warhol came
to Stockholm for his exhibition. The facade of the
museum was covered with his cow wallpaper. His
film *Chelsea Girls* was shown and was purchased
along with a painting. During the summer a
reconstruction of pioneer Russian Constructivist
Vladimir Tatlin's *Monument to the III
International* (1919) was made and shown.

Pontus Hultén:
*The reconstruction of Tatlin's Tower for the III
International from 1920 is the result of many
united efforts. Troels Andersen's research on
Tatlin has been of fundamental importance. The
interview with T.M. Schapiro, Tatlin's assistant
during the construction of the tower in 1919-20,
which Troels Andersen was able to conduct in
Leningrad in 1967, cast light on several shadowy
aspects of the tower's construction and gave us
the courage to carry on. For a time we hoped that
Schapiro, in accordance with his promise, would
come to Stockholm to help us.*

*The professors at Stockholm's Academy of Fine
Arts, Ulf Linde and Per-Olof Ultvedt, had worked
for months attempting to build a 1:10 scale model
in the winter of 1967-68 and became familiar
with every detail on the four photographs, which
were all there was to go on. They interpreted the
confusing retouched photographs with such
assurance that others who were less familiar with
them were astonished. The preparatory model
they constructed was a masterpiece in itself.*

*The carpenters Arne Holm and Eskil Nandorf
have built the tower using the little model as their
starting point. They have done this with
extraordinary expertise, initiative, inventiveness
and dedication. Henrik Östberg has cut the metal
fixings ... They are beautifully done.*
(From the foreword to the exhibition catalogue.)

The Tatlin *Tower* has since been widely shown.
Other Tatlin reconstructions have been
subsequently donated to the museum including a
chair that he designed, his man-powered flying
machine *Letatlin* and his stage set of the *Moon*.

In the autumn children took over the museum.
One of the galleries was vacated to make room
for *Modellen* (The Model) where children were
invited to dress up, paint and discover the possi-
bilities inherent in different materials. This experi-

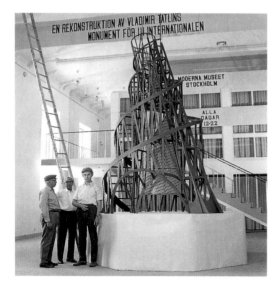

The three carpenters in front of the reconstruction of Tatlin's *Tower*; Eskil Nandorf, Hendrik Östberg and Arne Holm 1968

ment led to a workshop in one of the galleries, which gave children from schools and nurseries the opportunity to make things themselves rather than being taught by a museum lecturer. Showing children art, letting them talk about what they had seen and experienced and then spending a while painting or modelling in their own workshop has been an important aspect of the museum's activities ever since. While the children were at the museum, Eva Aeppli's textile sculptures were being shown in a neighbouring gallery.

1969
Alvar Aalto, one of the greatest modern architects, was the subject of an exhibition. In the same year the works of Max Ernst, Sven Erixson and an exhibition on the theme *Poesin måste göras av alla! Förändra världen* (*Poetry must be made by all! Change the world*) were also shown. The poetry in question reflected the radical spirit of the time and might be as diverse as a mask from New Guinea, Tatlin's *Tower*, a Surrealist object, slogans from Paris in spring 1968 or a film by Buñuel ...

1970
In 1970 the American Pop artist Edward Kienholz presented his bleak view of contemporary life in eleven tableaux; the German artists Berndt and Hilla Becher showed their photographs of industrial buildings.

1971
Joseph Beuys and Paul Thek both installed exhibitions of their work.

The Fotografiska Museet was established in 1971 when the Fotografiska Museet's Friends Association entrusted their collection of photographs to the Nationalmuseum. During the following years several organisations such as The Swedish Photographers Association, The Swedish Tourist Organisation, The Swedish Tourist Traffic Organisation, The National Association of Swedish Photography, the TIO group of photographers and private persons made donations to the collection. All of these donations were combined with Helmut Gernsheim's Duplicate Collection and Professor Helmer Bäckströms Collection, which had been acquired in 1964 and in 1965. Later that year the whole collection of photographs and photographic literature was unified and transferred to Skeppsholmen.

1972
A retrospective of the work of Jean Tinguely took place. Pontus Hultén's book on the artist was published in conjunction with this and a unique donation made in the previous year – *Le paradis*

fantastique (1963), a group of sculptures originally made by Tinguely and Niki de Saint Phalle for the Montreal EXPO, was installed outside the museum. Ever since then de Saint Phalle's Nanas and Tinguely's machines have caressed each other close to the museum as a sort of offspring of *SHE*.

1973

During the early 1970s Pontus Hultén was active in organising a further important donation for the museum. In the autumn of 1973 The New York Collection was opened.

Pontus Hultén:
In November 1971, Billy Klüver asked me to come to New York to discuss a project that had by then been in the picture for some months. The point at issue was whether it was worth trying to make up a collection of important works created by American and European artists active in New York during the 1960s, and if so where such a collection should be housed.

Billy Klüver is one of Moderna Museet's oldest friends – from the time he had been working in Paris, in the mid-1950s, and had helped us to procure films for our earliest film series.

I had the pleasure, during two stays in New York in my sabbatical year from Moderna Museet, of selecting in cooperation with the artists some thirty works that we hoped to acquire. If the reader has not already asked the question, he will do so at this point: where does the money come from? American legislation allows private persons, foundations and corporations to donate money for purposes of public utility, both in and, in certain circumstances, outside the United States, and thus make a greater or lesser deduction from taxes. This is in accordance with American economic theory that it should be possible to support entirely private initiative with state

money. The idea, then, was to persuade private persons, foundations and corporations to support the project by donations.

It can hardly have surprised anyone that I began, as soon as I was involved in the project, to investigate the possibilities of assigning the collection to Moderna Museet in Stockholm.

It is difficult for me to express how delighted I am that this donation has come about. Moderna Museet was created in the late 1950s, and it is natural that the art of the 1960s should have become its first speciality. The existing collections of Swedish, European and American art of the 1960s are respectable enough, but they lack breadth. It will not, surely, be denied that some of the most important contributions to world art, and to the new view of art that was born in the 1960s, were made by artists in New York.
(From the catalogue to the exhibition New York Collection for Stockholm)

Rauschenberg designed the poster and Robert Whitman the cover of the catalogue. The collection included a painting by Andy Warhol and one by Kenneth Noland as well as works by Donald Judd, Sol LeWitt, Claes Oldenburg, Ellsworth Kelly, George Segal amongst others.

Fotografiska Museet began a programme of exhibitions and lectures. During the rebuilding of Moderna Museet these activities took place in Kasern 3 on Skeppsholmen where the Royal University College of Fine Arts is housed today. As part of the reorganisation of the Nationalmuseum's collections Fotografiska Museet became a department within Moderna Museet. In Christmas its activities moved into the west gallery in Moderna Museet.

1974

The New York Collection proved to be Pontus

Hultén's last major effort for Moderna Museet and his parting gift. He now moved to Paris as the founding director of the new museum at the Centre Georges Pompidou. The new director of Moderna Museet was Philip von Schantz, a Swedish painter. During his first year there were retrospectives for two Swedish artists – Torsten Renqvist and Evert Lundquist. In 1974 the old Drill Hall was closed for rebuilding and the collection put into storage. This resulted in a new, spacious gallery, a large children's workshop, an auditorium, a carpentry shop and much else lacking in the old premises.

1975

On 7 November, Moderna Museet was inaugurated for the second time with a Henri Michaux exhibition and a mock underground station in which a poet – Rolf Börjlind, and a painter – Carsten Regild, both young Swedes, had written and painted 'pictures' with a challengingly anarchic content.

1976

In the summer the museum opened itself to a group of artists, architects, technicians and scientists – all of whom were deeply interested in alternative forms of research such as ecology, recycling and 'soft' technologies. Their often poetic houses and other human constructions were built outside the museum. The exhibition was given the name ARARAT, which stood for Alternative Research in Architecture, Resources, Art and Technology.

During von Schantz's time the financial means with which to make important acquisitions shrunk still more. Partly as a polemic against his predecessor and partly from his own bitter experience, he wrote the following lines on the role of director.

Philip von Schantz:
One wanted to buy early before works became too expensive. Of ten acquisitions one hoped that there was at least one important work in the net. One was not always successful. And a purchasing committee consisting of colleagues is not good either; back-scratching and compromises are close to hand. If the museum takes the time to follow an artist for a period the chances of buying the right picture by the right artist increase. This is not necessarily more expensive.

The difficulties today are even greater. The number of artists has increased dramatically. Works of art are often technically fragile or bulky. How many giant paintings and installations can a museum house? That contemporary art should be shown at a museum of modern art is obvious but why be in such a hurry to expand the collections? All the art that is purchased with public money does not have to belong to a museum and, at any rate, not be locked up in a museum store.

As an artist and viewer I have, finally, a question. Why are the acquisitions of international contemporary art by the modern museums so appallingly conformist? Does the intimate collaboration between curators from different countries necessarily have to result in exhibitions and collections being almost identical?
(From *Moderna Museet Stockholm*, Bonn 1996)

1977

A small Giacometti exhibition was shown. 13 artists from Finland showed paintings, sculptures, photographs and conceptual art. A young musicologist produced a selection of visually interesting musical notations. In a nearby building an exhibition showed room upon room of contemporary or timeless death-defying attitudes to humanity.

In the autumn Claes Oldenburg returned with an exhibition of drawings. Philip von Schantz departed. Karin Lindegren took over as Director.

1978

Since the middle of the 1960s Lindegren had been a curator at Moderna Museet but for a period she had been working as Swedish cultural attaché in West Germany. She now returned to her former place of work and, in her two years as director, she produced several exhibitions inspired by a different cultural climate. Several of the exhibitions from these years can be seen as contributions to a wider debate.

In 1978 *Tusen och en Bild* (*Thousand and One Images*) was shown at Fotografiska Museet. It was a rhapsodical survey of the rise and development of photography. The show was also an indication of the photographs that the museum wished to add to the collection.

Almost two hundred photographic exhibitions have been shown up to the present including *Genom Svenska Ögon* (*Through Swedish Eyes*) 1978-79. *Bäckströms bilder!* (*Bäckströms Pictures*), *Se dig om i glädje* (*Look back in Joy*) 1981, and *Bländande bilder* (*Dazzling Pictures*) 1981-82.

1979

At the end of the year Öyvind Fahlström's posthumous retrospective exhibition opened. This had been planned with the artist before his death three years previously. The exhibition subsequently travelled to the Musée National d'Art Moderne in Paris.

1980

For the next decade Olle Granath was the museum's director. The exhibition programme was a balance of Swedish, international, younger and classical art. During these years such masters as Chagall, Picabia, Matisse and Picasso were shown alongside Swedish artists Eddie Figge, Olle Baertling, Hilding Linnqvist and Lennart Rodhe. Granath's contacts in Poland resulted in the exhibition *Dialog* in which eight Polish artists conversed with eight invited international artists through their work and friendship.

1981

A group exhibition grew out of the comment that the museum had failed to show anything of 'new German painting' which included Markus Lüpertz, A.R. Penck, Per Kirkeby and Jörg Immendorff.

Individual artists were still invited to exhibit. During the 1980s there were shows of work by Joel Shapiro, On Kawara (1980), Marcel Broodthaers (1982), Mario Merz (1983), Daniel Buren, Jonathan Borofsky (1984), Bill Viola (1986), Walter De Maria (1988) ... Robert Whitman came and reconstructed some of his older performances and also premiered a new one.

1983

A touring exhibition of Russian avant-garde art from George Costakis' collection was shown. The great collector wanted to donate a work to Moderna Museet – what did the museum want? A cautious request was a Malevich. And Costakis donated the artist's beautiful portrait of his daughter. A large retrospective of the photographs by Henri Cartier-Bresson also took place.

1984-86

In 1984 *Vanishing Points*, which focused on work made in New York between 1965 and 1970, opened with the following artists: Mel Bochner, Tom Doyle, Dan Graham, Eva Hesse, Sol LeWitt, Robert Smithson and Ruth Vollmer.

Olle Granath:
Why Vanishing Points, almost 20 years on? First of all, because four of the seven are still fully active in our midst, characterising our age at least

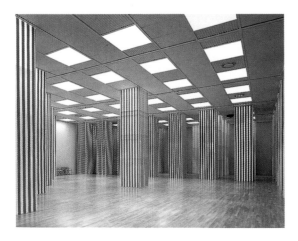

Daniel Buren, *Coincidences*, 1984

as strongly as much of what is appearing with a
self-assumed entitlement to speak for the times.
But perhaps above all because we have a tendency
to be careless with some of the ideas that once held
these artists together, in spite of their differences.
We have here the emphasis on the route rather
than the goal; we find no false polarisation
between the individual and the world, whether the
world is that of Nature or Society. We find in
their works a social quality which never ceases to
be the criterion of a significant work of art; we
find a self-criticism, applied both to the validity of
their own statements, and to the range and viability
of their medium. Their works are surrounded by
air in which we can breathe; at the same time they
refuse to let us forget that our destinies are
conjoined with the destiny of the world.
(From an article in the exhibition catalogue)

In the same year the historical exhibition
Fotografier från Bosporen och Konstantinopel
(Photographs from the Bosphoros and Constan-
tinople) was shown. In 1985 a first retrospective
of Irving Penn's photographs was held.

1987
The fundamental changes that had recently taken
place in architecture, philosophy, critical theory
and art were addressed by curator Lars Nittve in
the exhibition *Implosion – a post-modern
perspective* (*Implosion – ett postmodernt
perspektiv*).

Lars Nittve:
*Even if discussions of Postmodernism in art
have been fairly sporadic, and indeed markedly
confused, here in Sweden, it should not come as
any surprise that this major Postmodern
exhibition has been created by the Moderna
Museet, in Stockholm. It can be seen as a
natural continuation to the succession of radical
exhibitions that was started as early as in the
1960s, with, for example,* 4 Americans *(1962),*
American Pop Art *(1964), and* Andy Warhol
(1968) and is continuing in the 1980s with
Marcel Broodthaers *(1982),* Daniel Buren *(1984)
and* Vanishing Points *(1984). At the same time,
the exhibition interacts in a self-evident manner
with the Museum's own collections, in which the
works of Marcel Duchamp and Francis Picabia,
and of the American Pop artists and Minimalists,
occupy a central place.*
(From the foreword to the catalogue)

Among these post-modernists were Barbara
Kruger, Louise Lawler, Sherrie Levine, Allan
McCollum, Gerhard Merz and Cindy Sherman.

1988
Barnett Newman's sculpture *Here I* was donated
to the museum by the artist's widow.

1989
The museum gratefully received Gerard Bonnier's
bequest of 24 masterpieces. Bonnier had been a
long-time supporter of the Museum and its
Friends and the collection was greatly enriched

by his generosity.

Ulf Linde:
*Gerard had gone round the museum to see what
was missing: the two paintings by Mondrian
did not suffice to show who Mondrian was –
another was needed ... Three good sculptures
by Giacometti but not one that showed his
feeling for movement; some walking figures
were necessary and a painting! ... And there was
only a single Picasso from his best period, the
years around 1930; it was not enough to show
how rich his imagination was at that particular
time ... Of Klee, there was nothing between the
very early and the very late ... Of Yves Klein
there was nothing that helped one to understand
that blue stood for something that was not blue,
something in gold was needed ... And why was
there not even one Jacques Villon? ...
All at once Moderna Museet's collection had
become complete, intense. In no single case had
Gerard donated a duplicate with the sole function
of showing off his name on a label. It was the
collection that was to survive!*
(From 'Samlandet som konst' ('Collecting as Art')
in *Donation Gerard Bonnier* (*The Gerard Bonnier
Bequest*), 1989)

During his last years at the museum Olle Granath
took part in planning a new building for the
museum. Funds were raised for an architectural
competition for invited architects.

At the end of 1989 Olle Granath was appointed
director of the Swedish National Art Museums
and continued to be close to Moderna Museet and
to work for the new building. That autumn Björn
Springfeldt took up the post of director.

1990-1992
In the winter of 1990-91 an architectural
competition was held for a new Moderna Museet.
Over 211 proposals were received and these were

all shown in the Museum. With funding from the
Eddie Figge Foundation five internationally
renowned architects were invited to participate.
These were Tadao Ando from Japan, Frank Gehry
from the USA, Kristian Gullichsen from Finland,
Jørn Utzon from Denmark and Rafael Moneo from
Spain. On April 10, Moneo was anounced as winner.

Björn Springfeldt:
*At the first meeting with Moneo it was evident
that the museum had been extraordinarily
fortunate. Here was an architect who was more
interested in the museum's collections and in the
challenge of creating the best possible meeting
place between the collections and the public than
of promoting his own architectural expression.
Rather, Moneo has let the building express itself
through a masterly sense of proportion and in his
care for the minutest details. The exterior is both
characteristic and powerful and, at the same time,
modest and is able to fit quietly into the island's
sensitive environment without making itself
invisible.*
(From *Moderna Museet Stockholm*, Bonn 1996)

Springfeldt had worked at the museum since 1968
and, like his two immediate predecessors, knew
the collection well. But in the years prior to his
appointment he had successfully directed the
Malmö Konsthall in the south of Sweden. From
there came the exhibition which he had produced,
Kandinsky och Sverige (*Kandinsky and Sweden*),
which was shown in Stockholm as he was starting
as director. (Two years later another exhibition of
Fernand Léger documented this major painter's
relationship with Scandinavia. This research into
what was often a short period in a rich career was
something new. Although academic in the eyes of
many, this method enabled the production of
small and intense exhibitions.) The Kandinsky
exhibition was followed by *Spegling* (*Mirroring*)
showing young Swedish art. This was followed by
a succession of exhibitions of young American
artists: Ross Bleckner (1991), Kiki Smith (1992),

Lee Jaffe (1992) and the retrospectives of Swedish artists Lage Lindell and Arne Jones (1993).

Moderna Museet continued to offer visitors the very latest work. During the early 1990s photography occupied an increasingly important place and this also gave rise to a number of important acquisitions for the collection.

1993-97
In May the old Drill Hall on the former naval island in central Stockholm was closed after 35 years. The last exhibitions were a large retrospective of the work of Gerhard Richter and of photographs by Alfredo Jaar.

The museum purchased 200 works by Scandinavian artists from The Fredrik Roos Collection, most of whom had made their debuts in the 1980s.

During the building work Moderna Museet occupied temporary premises in a former tram depot in the city centre where a number of important temporary exhibitions were shown. These included displays of the permanent collection as well as such exhibitions as a retrospective of Jan Håfström, recent works of Gary Hill, the private collection of Carl Gemzell, which included 14 works by Paul Klee, an exhibition showing the emerging generation of young Swedish artists and the first retrospective in Sweden of works by Alexander Calder.

While Moneo's new museum was beginning to rise on Skeppsholmen, and as the end of the period in the old tram depot came into sight, Björn Springfeldt retired as director to take up the post of cultural attaché in Germany. Among his last contributions was that of negotiating with Irving Penn a donation of 100 photographs for the collection. This was shown in Stockholm at the end of 1995 and is still touring to other venues.

1996
In July the exhibition *Moderna Museet Stockholm* was opened in the Kunst und Ausstellungshalle der Bundesrepublik Deutschland in Bonn. Pontus Hultén, the German gallery's former artistic director, had, with Björn Springfeldt, selected some 250 works from the collection, which they themselves had helped to nurture. A selection from this exhibition toured to four museums in Japan during 1997.

In November David Elliott, who had previously been director of the Museum of Modern Art in Oxford, England, became director; the first non-Swede to take up the post.

1997
The last show at the tram depot in February was *Picasso and the Myths of the Mediterranean,* which focused on the artist's relations with the different cultures of this region. In 1956 when the drill hall at Skeppsholmen was first transformed into a museum of modern art Picasso's *Guernica* had been shown in the building, while it was still under reconstruction. Now, some 40 years later, in a similar period of rebuilding this circle was completed. The gallery at the tram depot was closed in May.

1998
The new museum was finally opened by the King and Queen of Sweden on 12 February 1998 during its 40th anniversary year. Over 30,000 20th century prints and drawings were transferred from the Nationalmuseum to Moderna Museet. The first exhibition *Wounds: between democracy and redemption in contemporary art* traced developments in Europe and America from the 1960s to the present day. This provided a bridge between the frenetic and visionary activities of the Museum's early years and the no less stimulating and dynamic possibilities of the present and future.

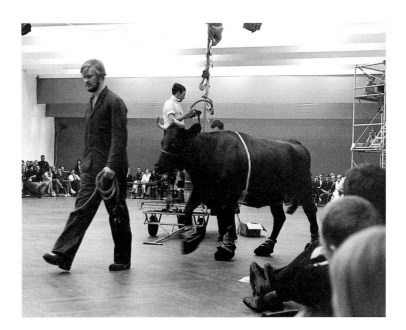

5 New York Evenings, 1964.
Cage, Cunningham, Tudor, dancers
and a cow invade the museum's
galleries during a week in September

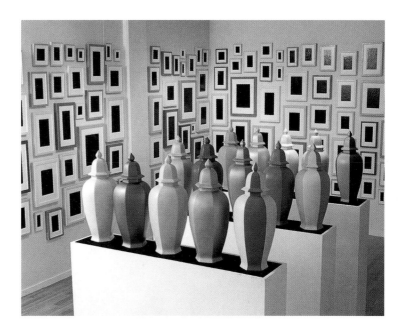

Implosion, 1987
Allan McCollum's room in
the exhibition

Highlights from the Collection

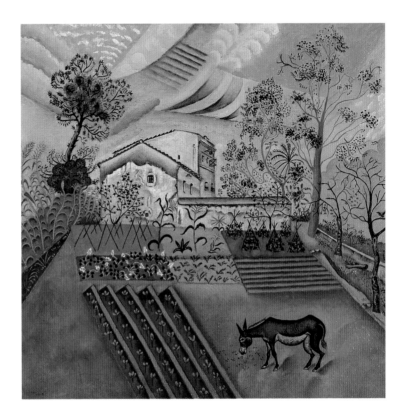

Miró, Joan
Spanish
1888-1983

Le potager à l'âne
The Donkey in the Kitchen Garden
1918

Oil on canvas
64 cm x 70 cm
Purchased 1965

Aguéli, Ivan
Swedish
1869-1917

Flickporträtt
Portrait of a Girl
1891

Oil on cardboard
59 cm x 39 cm
Purchased 1940

Aguéli left his native Sweden in 1890 and only returned for short visits from 1891-94, making long trips to Egypt and Spain throughout his career. Having been introduced to Cézanne and Gauguin by his teacher Emile Bernard, he 'followed Cézanne's road'. A theosophist and anarchist, he put up active resistance to cruelty to animals and converted to Islam. During the years 1900-12 he stopped painting altogether, turning to art criticism. He resumed painting in 1912-13.

Works by artists such as Matisse, Picasso and Kandinsky usually introduce the foreign collections in modern museums; their contemporary, Ivan Aguéli, is a key figure in the Swedish collection. If it is true to say that Matisse rejected a grey-brown academicism during his Fauvist years, and if Picasso achieved a special atmosphere in his blue and rose periods, and if Kandinsky lifted the literary veil from Russian landscape painting, then Aguéli introduced an even simpler architecture in his often small paintings.

He was taught by the French painter and writer Emile Bernard:

> I put Aguéli in my school. I intended to teach him various painting techniques. I let him produce simple things 'ornées d'un trait et colorées par des gradations, mais sommaires' (drawn in one single stroke and coloured in summary gradations).

(Emile Bernard, quoted in Axel Gauffin, *Aguéli*, 1940)

Flickporträtt (*Portrait of a Girl*) was painted after Aguéli visited Bernard in the summer of 1891 on Gotland. The girl was a sweetheart whom he painted many times, always using the same blue. In this, an unusually severe work, he achieves an unprecedented vitality.

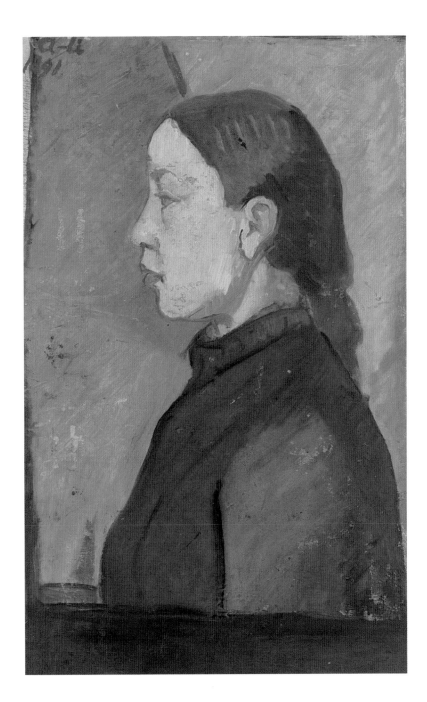

Arbus, Diane
American
1923-71

Young Patriot with Flag
1967

Gelatin silverprint photograph
38.3 cm x 37.1 cm
Purchased 1978

After working in commercial and fashion
photography for about 20 years Arbus
became interested in the medium as an
art form. She enrolled at the New School
of Social Research – a meeting-place for
artists, writers and musicians at the time.
Her teachers included the photographer
Lisette Model whose pictorial style, concern
with issues of identity and interest in the
unattractive, often extreme aspects of
humankind became decisive for Arbus'
development. Other influences were Louis
Faurer and Robert Frank with whom she
also became acquainted.

Arbus planned her works meticulously, choosing her subjects and
settings with great care and seeking out distinctive characters and
individuals such as nudists, transvestites or cabaret and variety
artistes. Interested in the use of light, she experimented with flash
and followed up in the dark room by using the tone values of
her black and white images to underline the message of the
photograph. Her penetrating and compassionate pictures
concentrated on unexplored aspects of human life: people who,
due to their physiognomy or their way of life, had been rejected
by society, or vulnerable figures who expose themselves to great
social risk. Arbus avoided all optimism, seeming to prefer the
more anguished aspects of human nature. Her quest was perhaps
an attempt to mirror her own self.

In 1963 and 1966 Arbus received Guggenheim Bursaries for her
project *American Rites, Manners and Customs*. After her untimely
death in 1971 the Museum of Modern Art in New York arranged
a retrospective exhibition of her pictures, which toured for seven
years in the USA, Europe and Asia. The Moderna Museet's
collection of Diane Arbus' photographs was purchased in 1978 in
connection with the exhibition *Tusen och en bild* (*A Thousand
and One Pictures*).

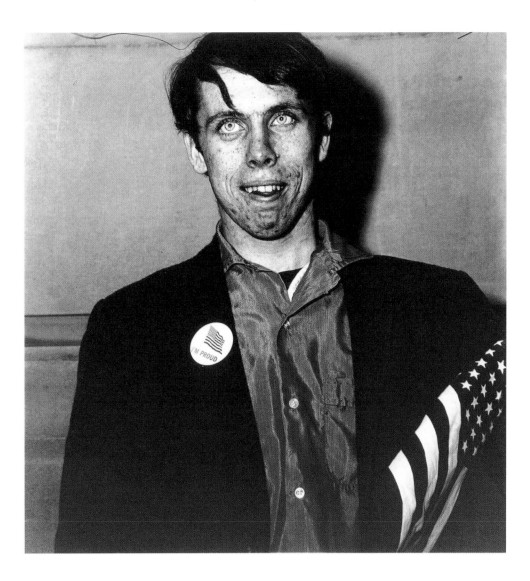

Bacon, Francis
British
1909-1992

Double portrait of Lucian Freud
and Frank Auerbach
1964

Oil on canvas, 2 canvases
165 cm x 287 cm
Purchased 1967

A self-taught artist, Bacon won recognition towards the middle of the 1940s with his Crucifixions and figure studies. Belonging to no particular school, his work is characterised by an emphasis on horror, loneliness and despair, the tortured subjects often enclosed within a box or vitrine of unreal perspective. His most famous works are a series of paintings of popes, inspired by the works of Velázquez.

Bacon's models in this double portrait are the painters Lucian Freud and Frank Auerbach. Both were born in Berlin, in 1922 and 1931 respectively, but lived and worked in Britain and became friends of the artist:

> *Even in the case of friends who will come and pose, I've had photographs taken for portraits because I very much prefer working from photographs than from them. It's true to say I couldn't attempt to do a portrait from photographs of somebody I didn't know. But, if I both know them and have photographs of them, I find it easier to work than actually having their presence in the room. I think that if I have the presence of the image there, I am not able to drift so freely as I am able to through the photographic image. This may be just my own neurotic sense but I find it less inhibiting to work from them through memory and their photographs than actually having them seated there before me.*

(from David Sylvester, *Interviews with Francis Bacon*, 1975)

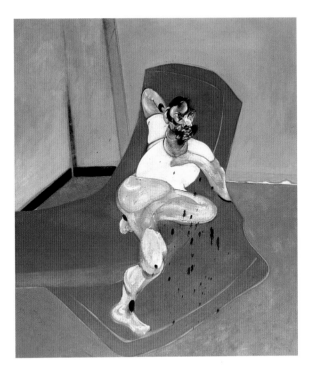 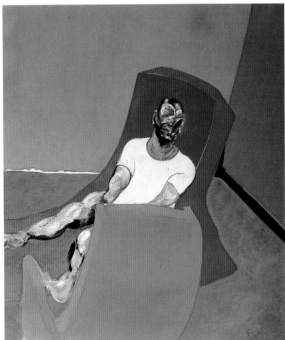

Balla, Giacomo
Italian
1871-1958

Velocità di una automobile + luce
The Speed of a Car + Light
1913

Oil on paper mounted on canvas
84 cm x 109 cm
Purchased 1967

In 1900, Balla went from Italy to Paris,
where he saw the works of the
Impressionists for the first time. He
worked for a while in the Divisionist style
until 1909, when he was introduced to the
theories of the Futurists by the poet Filippo
Tommaso Marinetti. Having signed the
Futurist Manifesto he began to analyse
the individual moments and mechanisms
of movement in images such as a running
dog or a speeding car.

The year is 1913, Balla is 40, his fame a certainty, his position secured so to speak ... but this unafraid and really bold painter ... One must not stop, one must renew oneself, act, not carry on in the tradition, but go past it ... and ... create the kind of art which describes the true expression in a nation and which leaves behind the distinctive traits of an era ... and after he has cast a glance at his surroundings, he lives life, cheekily, rebelliously, alone in the sleeping crowd, and in indifference among the sceptics Marinetti, Boccioni, Russolo and Severini and in their company ... a new suffering was started (the new struggle). But the mob will never understand which occult forces create the resistance in the divine powers in the person who has the right faith ... this Balla who has cut off his beard and his hair, and taken off his cravat, which pinched his neck, who has thrown away the thin mantle, fresh-looking and newly shaved, he has put on his collar and starched cuffs and a suit à la mode.

(from an autobiographical note reproduced in M. Drudi Gambillo, T. Fiori, *Archivi del Futurismo vol II*, 1962)

34

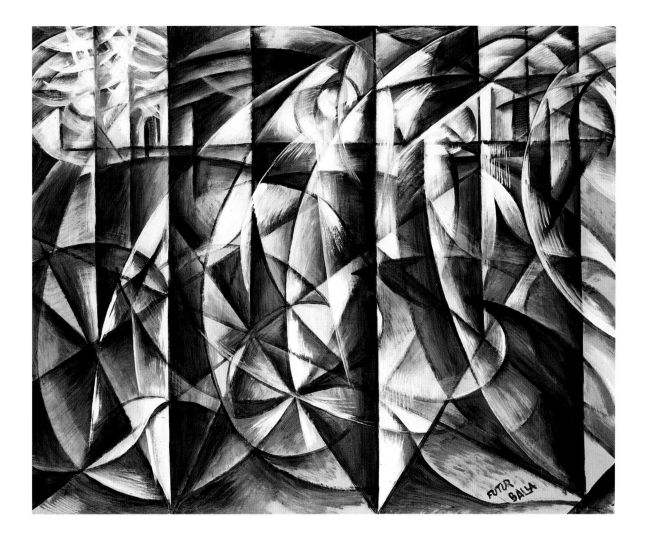

Beuys, Joseph
German
1921-1986

Hasengrab V (die Alpen)
Hare Tomb V (the Alps)
1965

Mixed media
23 cm x 92.5 cm x 46 cm
Gift 1971 from Moderna
Museet's Friends Association

As a pilot in the German air force during the Second World War Beuys was shot down in the Soviet Union. Found by nomads and wrapped in fat and felt, his life was saved. This event, and these materials, became a recurring feature in his art. A political activist and leading member of the Fluxus movement whose work has concentrated on shamanistic 'happenings' and the cult of the artist, Beuys has also been associated with Arte Povera and Anti-Form.

My objects are to be seen as stimulants for the transformation of the idea of sculpture, or of art in general. They should provoke thoughts about what sculpture can be and how the concept of sculpting can be extended to the invisible materials used by everyone.

Thinking Forms –	*how we mould our thoughts or*
Spoken Forms –	*how we shape our thoughts into works or*
SOCIAL SCULPTURE –	*how we mould and shape the world in which we live: Sculpture as an evolutionary process; everyone an artist.*

That is why the nature of my sculpture is not fixed and finished. Processes continue in most of them: chemical reactions, fermentations, colour changes, decay, drying up. Everything is in a state of change.

(from an interview with Beuys, published in his exhibition catalogue for The Solomon R. Guggenheim Museum, 1979)

We do not know whether the dead hare is actually concealed under the little heap of 'rubbish' crowned by the Swiss cross. The word 'dead' is, according to Beuys, an invisible material, a form of thought. The fact that he once said that 'everyone is an artist' does not have to mean that 'anyone' could have built this tenderly put-together work with its change of colour and sense of decay, drying out. Everything is in a state of change.

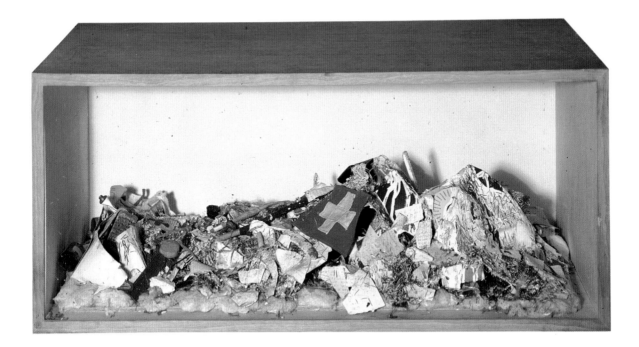

Brancusi, Constantin
Romanian
1876-1957

Le nouveau-né II
The Newborn II
c 1920

Marble
H 16.5 cm
Purchased 1961 with
contribution from Moderna
Museet's Friends Association:
Carina Ari, Gerard Bonnier,
Sten Hellner, Charles Nilsson,
Hildur Nordin, Ivar Philipson

Brancusi left Romania for Paris in 1904.
His ambition to capture in his sculptures
the 'essence' of things led him to work with
reductionist, simplified, universal forms
such as eggs and columns, using highly
polished marble, bronze and wood. Key
themes were rest, flight (often symbolised
by birds) and birth. After his death in 1957,
his studio at Impasse Ronsin was moved
to the Musée d'Art Moderne.

What does one see when looking at a newborn child?
A wide open mouth is snatching at air.

Each newborn child comes to the world angry because
it was brought there against its will.

(Brancusi)

Brancusi made this work for the Salon de Franc, an auction of
works donated by artists of foreign extraction who were resident
in France. Intended to stabilise the country's currency, the auction
was held on October 26 October, 1926, and the sculpture was
purchased for 7,000 francs by Rolf de Maré, Principal of the
Swedish Ballet. Insisting that the work should not be displayed
on a plinth, Brancusi placed the work on the floor in de Maré's
home. Later, in his apartment in Stockholm, de Maré kept the
sculpture on a green velvet sofa.

(Notes and quotations taken from *Brancusi*, 1987 by
Pontus Hultén, Natalia Dmitresco, Alexandra Istrati.)

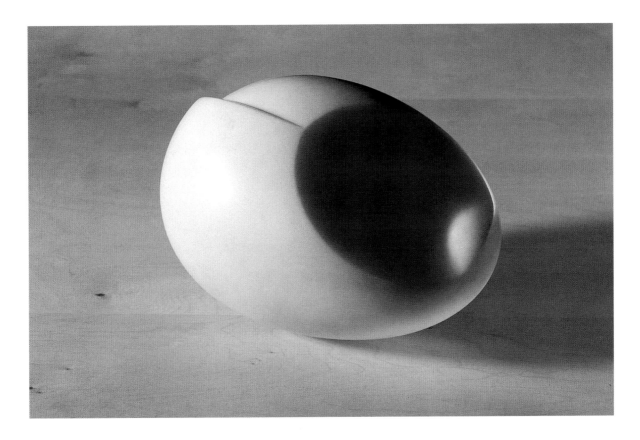

Braque, Georges
French
1882-1963

Right:
Le château de la Roche-Guyon
The Castle in Roche-Guyon
1909

Oil on canvas
80 cm x 59.5 cm
Gift 1966 from Rolf de Maré

Below:
Le compotier
The Fruit Bowl
1908

Oil on canvas
53 cm x 64 cm
Gift 1966 from Rolf de Maré

Apprenticed by his father as a house-painter, Braque moved from Argenteuil to Paris in 1900 where he began to produce Fauvist works. It was his close relationship with Picasso, and their subsequent invention of Cubism, that was to become central to his work. Braque's unique contribution to that movement was the introduction of the first collage. When he returned to Paris after 1916, his friendship with Picasso faded 'maybe because we did not need each other any more'.

It was the poet and art critic Guillaume Apollinaire who, in October 1907, had introduced the 25-year-old Braque to a slightly older Picasso. Braque, who up to that time had painted landscapes in a Fauvist mode, 'à la Matisse', was soon to change his entire style and approach to art. He devoted the following summer to several still lifes in subdued colours. Early in the autumn of 1908 he returned to Paris with the new paintings and handed them in to the annual Autumn Salon. The jury (which included Matisse) rejected all but one. Braque retaliated by withdrawing the work, exhibiting the paintings in Daniel-Henri Kahnweiler's gallery instead. When Matisse saw the exhibition he reputedly stated that the paintings looked as if they consisted of small cubes. he concept of Cubism was born.

That autumn Braque painted *The Fruit Bowl*. The reviews were devastating and in many quarters he became an object of scorn, but he had the full support of Apollinaire, Kahnweiler and Picasso and 'the new style' held. During the following years leading up to the outbreak of the war, Picasso and Braque would start a laboratory of painting. The two artists spoke the same language, and, each in his own studio, often arrived at the same result. Through their experimentations they found that it was possible to give the impression of volume without the aid of shading. By turning the 'round into the square' in what they called the '*tableau-objet*', a sense of reality could be imposed in a different way. Perceiving the object from different viewpoints at the same time and conjuring the presence of an object through fragments and allusion they overturned the central perspective that had dominated Western art since the Renaissance.

In the summer of 1909 Braque visited the village of la Roche-Guyon. 'The landscape is really very beautiful', he wrote to the dealer Daniel-Henri Kahnweiler, 'I want to be as undisturbed as possible. I beg you not to pass on my address to anyone.'

This self-imposed isolation yielded results: eight paintings from the village, five of which were of the medieval fortress. The trees and the limestone of the ruin encouraged Braque to intensify the colour to emerald green and brilliant yellow. But this was to be his last concession for some time to local colour. By the autumn he had greatly reduced his tones, and in the following years – together with Picasso – he eliminated all colour except black, white and ochre.

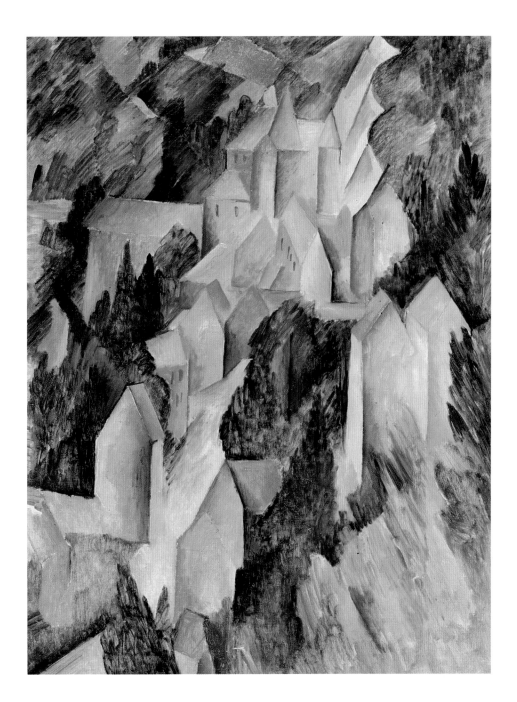

Calder, Alexander
American
1898-1976

Pantograph
1934

Painted wood, steel wire,
sheetmetal, motor
90 cm x 113 cm x 56 cm
Gift 1961 from Louisa and
Alexander Calder

Trained as an engineer, Calder moved from
Philadelphia to New York in 1923 where he
made his first sculptures. In the early 1930s
in Paris he became acquainted with Arp,
Léger, Mondrian and Miró. Inspired by
Mondrian's use of blocks of colour that
seemed to be suspended in mid-air, Calder
devised his hanging and moving sculptures,
which were named 'mobiles' by Duchamp,
His parallel, static, floor-bound works were
christened 'stabiles' by Arp. His monumental
group of mobiles, *The Four Elements, made
for the 1939 World's Fair in New York,* can
be found outside the Moderna Museet.

Calder donated this sculpture to Moderna Museet during his
visit to Stockholm for the exhibition *Movement in Art* in 1961.
A pantograph is an instrument for copying a plan or drawing on
a different scale by a system of jointed rods. In this work a small,
soundless motor causes rhombic steel wires, topped by circular
discs to stretch and shorten. However beautifully the steel forms
expand and contract, outlining each other vertically and
horizontally, however well proportioned and simply designed the
black box, Calder's poetic purpose was for the viewer to disregard
these elements and to follow the constantly changing positions
of the three circles in space. Consequently, the mechanism of the
sculpture is subordinated to the metaphor of earth, moon and
sun moving in an inner universe. The image of the freely soaring
object, is the image of freedom – in Calder's words: 'freedom
from the earth'.

Calder eventually abandoned the mechanism of the motor for the
capricious, dancing mobile, set into motion by currents of air.

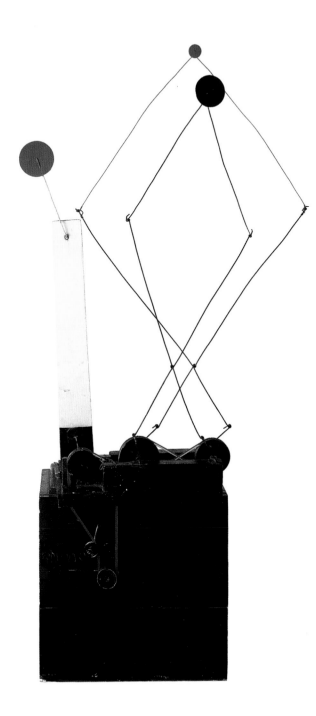

Cameron, Julia Margaret
British
1815-1879

Mountain Nymph, Sweet Liberty
1866

Albumen silverpoint photograph
36.5 cm x 28.4 cm
Purchased 1964

Cameron began taking photographs at the age of 48 with a camera given to her by her eldest daughter. She learnt the art from – among others – the Swedish-born Oscar Gustave Rejlander. After developing her skills through the study of photo chemistry and camera technique she attracted much attention through her portraits. Pictorially, she was inspired by contemporary British artists such as the Pre-Raphaelites Dante Gabriel Rossetti and George Frederick Watts. Her models were made up of her family and neighbours on the Isle of Wight and better-known personalities of the Victorian era, including Watts and his wife, the actress Ellen Terry, the scientist Charles Darwin, author Sir Henry Taylor, historian Thomas Carlyle, the poet Robert Browning, Alice Liddel (who Lewis Carroll's model for *Alice in Wonderland*) and the astronomer and photographic pioneer Sir John Herschel.

Believing that the eye is not as sharply focused as the camera lens, Cameron sought verisimilitude by positioning the camera lens only a few centimetres in front of the model.

Even her early photographs caused a sensation. She was active in various British Photographic Societies, won several prizes and published a number of photographic albums. Since there was no technique for printing photographic reproductions on paper, these images had to be stuck in by hand.

Mountain Nymph, Sweet Liberty is one of Cameron's most valued portraits. It is not known who is represented in the picture but it is believed that she is a sister of a Cameron's friend Cyllene Wilson who had been adopted by the Cameron family. The title of the photograph is taken from *l'Allegro* by the 17th century English poet John Milton:

> *Come, and trip it as you go,*
> *On the light fantastic toe;*
> *And in thy right hand lead with thee*
> *The Mountain nymph, sweet Liberty.*

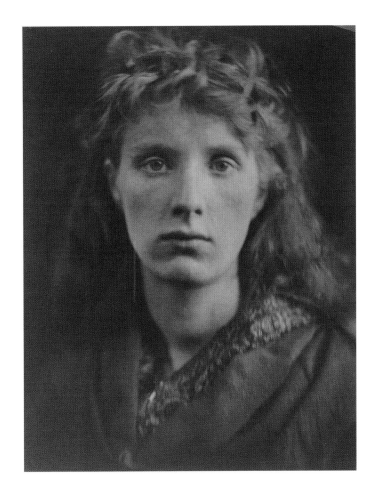

Chagall, Marc
Russian
1887-1985

Le vieillard et le chevreau
The Old Man and the Goat
1930

Tempera on paper
mounted on panel
54 cm x 65 cm
Gift 1989 through bequest
from Gerard Bonnier

Chagall grew up in the Jewish quarter of
Vitebsk in western Russia. He arrived in
Paris in 1910 and sampled the movements
of 'the new epoch', including Cubism, which
informs his work to some extent. But the
subject matter of his paintings remained
deeply rooted in the memories, dreams
and poetry of his Russian home town, its
people and its traditions. A retrospective
exhibition of his work took place at the
Moderna Museet in 1983.

Miró constantly declared his love for his native Catalonia, the
farmer and his soil – as if his paintings were nourished directly
from the earth. The work of Dalí too, owed much to the shores
and cliffs of Cadaqués. De Chirico remained faithful to the
deserted squares and empty houses of his childhood. The scenery
brought by Picasso from Spain in his luggage when he arrived
in Paris in 1901 remained with him for the rest of his life.

And Chagall had his Vitebsk. Whether he lived in Moscow, Paris,
Berlin or by the Mediterranean, the painter never lost his dream-
like memory of the timbered houses, muddy alleys, cows and
lovers, donkeys, drunkards, rabbis, old ladies, men and goats
of his home town:

> *My sad, and happy town!*
> *When I was a child I saw you with*
> *a child's eyes from our threshold.*
> *You were real in the child's eyes.*
> *When the fence stood in the way I climbed*
> *up on a small boulder. And if I still could*
> *not see you I climbed all the way*
> *to the roof. And, why not?*
> *Grandad also went up there.*
> *There was nothing in the way.*

> (Chagall)

The family was large and there were lots of role models in
Chagall's reminiscences from Vitebsk. In 1930 some old Jewish
men turned up, alone, abandoned – by God or by their own –
like this one, in the company of an equally deserted kid.

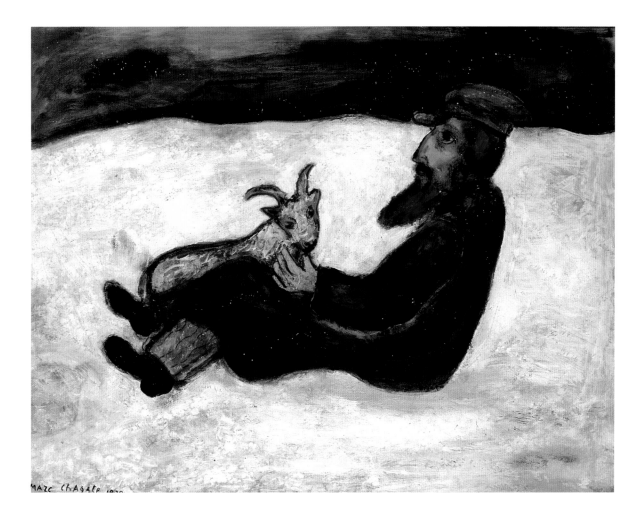

de Chirico, Giorgio
Italian
1888-1978

Le cerveau de l'enfant
The Brain of the Child
1914

Oil on canvas
80 cm x 65 cm
Purchased 1967

Born in Greece of Sicilian parents de Chirico
began producing his 'enigmatic' paintings
in Italy in 1910. These strange, uneasy
works of empty spaces, illogical shadows
and unexpected perspectives gave rise
to his theories of 'Metaphysical Painting'.
In order to find the essence and reality
of ordinary objects he stripped them of
their normal associations, placing them
in surprising locations or arranging them
in disturbing, theatrical settings. These
strange, dreamlike juxtapositions were
identified by André Breton as the first
phase of Surrealism.

This painting has never left me in peace since the day it was exhibited in Paul Guillaume's shop window in rue La Boëtie and it upset me so much that I got off the bus in order to look at it in peace and quiet. (1952)

It is probably because the curtain in de Chirico's The Child's Brain *– the most typical example of his work in 1914 – is only half drawn that I and many others feel so attracted to the painting ... In a period of grave external crisis – apparent or obscure – the presence of the curtain must be a sign of the need for one epoch to be superseded by another and be experienced as strongly as all the other elements in the painting. Thereby it offers resistance to the light of tomorrow. (1941)*

While Surreal art was still finding its feet this painting was always perceived as a 'clairvoyant' vision and had enormous influence on me and my friends ... The book's cover, which can only be glimpsed in the bottom corner, shows an abnormal bulge; it seems to be expanding, becoming flat as if the back cover and maybe even the last pages were missing ... Is it because he is closing his eyes, and in that case to what, which makes us so obsessed with the painting? In order to throw some light on the matter I had a photograph taken of the painting and with the help of retouching I showed two wide open eyes and called the whole thing The Awakening of the Child's Brain. *At first sight no one or almost no one noticed the change. (1954)*

(in André Breton, *Musée d'Art Moderne*, Paris 1991)

It is still not known when Breton bought this picture after the first upsetting encounter through the bus window – probably after 1919 and before 1922. It had been hanging in his apartment in rue Fontaine, where he moved in 1922, for more than 40 years when Moderna Museet persuaded him to sell it. The title is as enigmatic as the painting. The artist's title was 'The Ghost' but when Louis Aragon wrote a foreword for de Chirico's retrospective exhibition in Paul Guillaume's gallery in 1927 he took the liberty – in the name of surrealism – of renaming all the works.

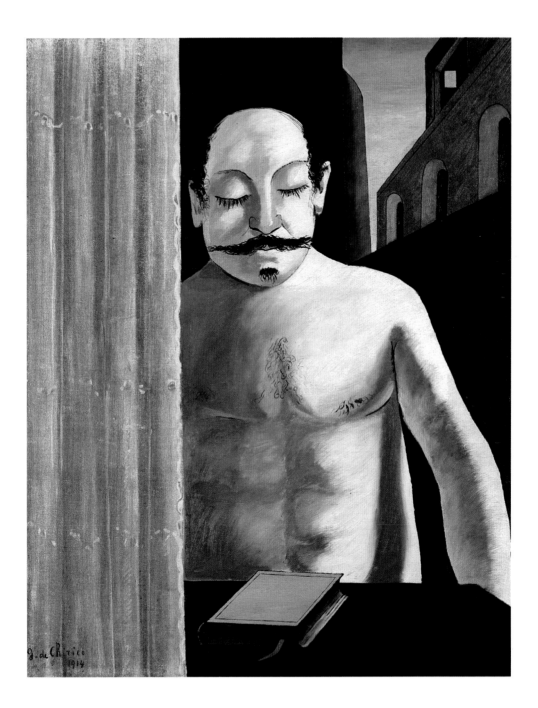

Cornell, Joseph
American
1903-1972

Rose Hobart
c 1939

16 mm, black and white tinted
film, (separate sound reel),
19.00 min, 16 frames per second,
Purchased 1980

For most of his life Cornell worked in New
York. He is best known for his 'boxes'
containing collections of objects and for
his Surrealist collages. From 1930 he began
to collect different forms of historical film
material, which he adapted and edited
into his own films. Since he was always
re-editing and reworking them, it is only
possible to guess at their dates. When, just
before his death in the early 1970s, Cornell
donated some material to Anthology Film
Archives in New York, 10 hitherto unknown
'collage films' were discovered.

Among the most important contributions to American experimental film was Joseph Cornell's film programme *Goofy Newsreels*, shown at Julien Levy's Gallery in New York in December 1965. In the audience was Salvador Dalí, who is said to have got up after the film show and turned towards Cornell with the words: 'You have stolen my ideas!' Whether this was why Cornell stopped showing his films to the public is uncertain, but in the 1950s and early 1960s some young film-makers did manage to see them. Among these were Larry Jordan and Jonas Mekas who were noticeably influenced, and it is Mekas and Jordan who have largely been responsible for saving Cornell's films for posterity. Jordan also helped Cornell with the final editing of several of them.

Rose Hobart, Cornell's first film collage, is largely a reworking of George Melford's *East of Borneo*, 1931, plus extracts from scientific films. *East of Borneo* follows the fortunes of the courageous and boyish Linda (Rose Hobart) who sets out on a dangerous journey to the principality of Maradu in Indonesia to look for her husband, a physicist (Charles Brickford) who turns out to have become an alcoholic and who is employed by a vicious prince (Georges Renevant). At the end of the film Linda wounds the prince and runs away with her husband. Shortly afterwards Maradu is destroyed by an eruption from a volcano, which lays waste the principality. In Cornell's adaptation a solar eclipse from another film has been added to represent the great catastrophe. The eruption of the volcano symbolises the prince's attempt to seduce Linda. The film's original soundtrack has been substituted with music from *Holiday in Brazil* played by Nestor Amaral and his orchestra.

Dalí, Salvador
Spanish
1904-1989

L'enigme de Guillaume Tell
The Enigma of William Tell
1933

Oil on canvas
201.3 cm x 346.5 cm
Purchased 1967

Trained at the Academy of Art in Madrid,
Dalí joined the Surrealist movement in
Paris in 1928. (Five years later he was
excluded from the group.) Like the
Surrealists he was interested in Freud's
interpretations of dreams and the
subconscious, but in his meticulously
painted, hyper-real works, he created
his own method and language of symbols,
which he called 'critical paranoia'. Together
with Luis Buñuel he made the films *Un
Chien andalou* (1928) and *L'Age d'or* (1931).

Kristian Romare (KR) *An explanation?*

Salvador Dalí (SD) *This is probably the painting which
describes one of the most dangerous moments in my life, yes, it is
called William Tell's enigma. William Tell, that is my father. The
little child which he carries in his arms ... instead of carrying an
apple on his head he carries a raw cutlet, which means that William
has bestial intentions. He wants to devour me. The spectators must
also notice that, beside William Tell's foot, there is a small nut, like
a cradle which contains a very small child, which is a picture of
my wife Gala, and who is always threatened by this foot, since the
foot, were it only to move a tiny bit, could crush the cradle and
the child and, consequently, it could also crush my wife. Sigmund
Freud has defined heroes in the following way: that person is a
hero who rebels against the paternal authority and who finally
defeats it.*

KR *This picture is painted at the time when the very young
Dalí rebelled against his father's authority, but nobody knew then
whether he would win or be defeated. That is the reason why the
picture is an ambivalent picture which describes the psychological
drama that exists in the surreal rebellion by the son towards his
father.*

SD *When the picture was painted there was actually a
possibility that William Tell, that is my father, might finally have
devoured me completely, like a cannibal and at the same time he
could have crushed the little nut with the smallest movement, the
nut which contains my wife Gala's delicate and very fine body,
the person - something which is well-known – I love best of all
in the world. Isn't that enough?*

KR *Is this still real to you?*

SD *There is ... I cannot estimate the time I have been writing,
painting, since I wrote a poem at the same time which is called
the same and I must confess that, although it is a long time since
I painted it, this picture is still an enigma to me today despite all
explanations I have given you, and that is the best thing one can
say about a work of art, since all great works of art always remain
enigmas, be it Vermeer's* The Studio *with himself painting,
Raphael's* The Marriage of the Holy Virgin, *or Velázquez's* The
Truce of Breda. *It must also be added that the real reason why a
painter paints is so that he can paint enigmas. If he already knew*

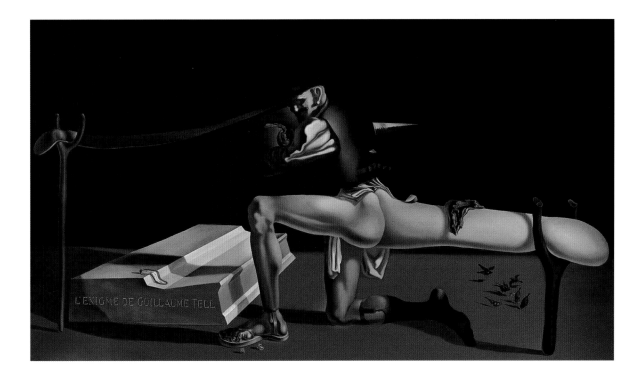

and understood in advance what he was to paint he would feel
no compulsion to do it. One paints because one owes the universe
new ultra-personal enigmas.

KR Thank you.

SD I hope that everything is very clear, but if it is too clear you
can always give me a ring and I'll try and make it more obscure.

(Interview with Salvador Dali by Kristian Romare on Swedish
Television, 17th July, 1967 on account of Moderna Museet's
purchase of William Tell.)

Dardel, Nils
Swedish
1888 -1943

Crime passionel
Crime of passion
1921

Oil on canvas
130 cm x 98 cm
Purchased 1927

After a brief spell at the Stockholm
Konstakademien, the dandyish
portrait-painter Nils Dardel went to Paris
to study. There he made grey, Cubist works.
After he moved to Senlis he started to use
stronger colours. Employed by Rolf de
Maré's Swedish Ballet, he was often called
upon as an intermediary in purchasing
works of art for de Maré. Towards the end
of his life he travelled extensively in South
America.

At the outbreak of the war, in 1914, Dardel was living in Sweden. Here he painted many interiors with figures engaged in relaxed social life. During the years that followed he made some long journeys together with his friend and protector Rolf de Maré. In Japan, during the summer of 1917, Dardel studied the composition and dramatic content of Japanese woodcuts with great interest.

Throughout his travels, Dardel lived in exotic environments, met both elegant people and people in rags, and, returning to Paris in 1919, experienced the salons of the decadents. He moved into a big studio in Montmartre, resumed his relationships with his artist friends and started his collaboration with Rolf de Maré and the Swedish Ballet. In 1921, the year he painted *Crime passionel*, he married Thora af Klinckowström.

The work illustrates Dardel's characteristic mixture of the anecdotal and the theatrical. Although the wounded person reflects Dardel's own dandyish image, it is improbable that this work refers to an actual episode in his life. More apparent is the influence of his new-found knowledge of choreography: the characters exaggerate the mannerisms of the ballet in a dramatic setting. Dardel was not keen on psychology, nor on the over-interpretation of the visual content of his works. However, this did not prevent him from correcting a museum tour-guide on one point: the pot carried by the housemaid does not contain tea but chocolate!

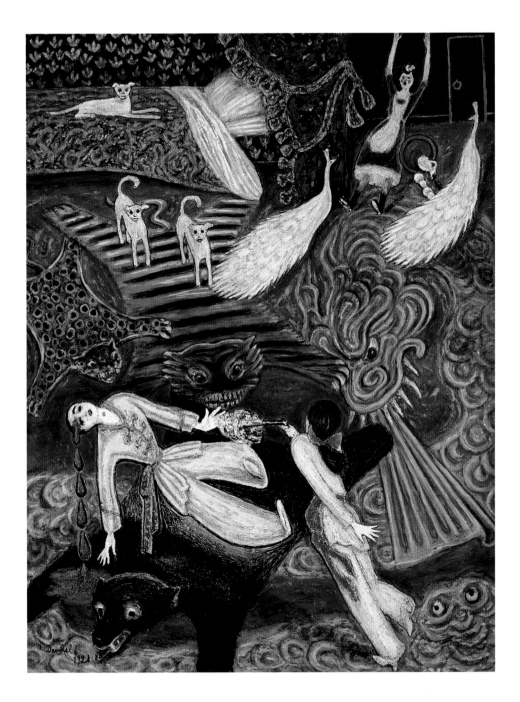

Duchamp, Marcel
French
1887-1968

La mariée mise à nue par
ses célibataires, même
The Large Glass: The Bride
Stripped Bare by Her Bachelors,
Even
1913-23

Replica made 1961 by Ulf
Linde and Marcel Duchamp
Gift 1961 from the artist
Replica made 1991-92 by
Ulf Linde, Henrik Samuelsson
and John Stenborg

Oil and lead on glass
283 cm x 189 cm

For a short while Duchamp, like his
brothers Jaques Villon and Raymond
Duchamp-Villon, belonged to the Cubist
group Section d'Or, but after 1912 and for
the rest of his life he remained outside all
'art life'. In 1915 he moved to New York
where he made the large painting on glass,
*La mariée mise à nue par ses célibataires,
même* and had made his first 'readymades',
such as the famous urinal work *Fountain*.
In the 1930s and 40s he gave the
appearance of ceasing all artistic activity,
helping his artist friends to sell their works
to museums and private collections and
taking part in chess tournaments. In the
middle of the 1940s he resumed his own
work – culminating with the painting
Étant donnés.

For his exhibition Rörelse i konsten (Movement in Art), *at the
Moderna Museet 1961, Pontus Hultén wanted to borrow* The Large
Glass *from Philadelphia in the United States of America. When this
proved impossible he had the idea that P.O. Ultvedt and I should
make a copy with the help of the reproductions and the notes in the
famous Green Box. We accepted – and Duchamp agreed – but
Ultvedt soon pulled out for reasons I can easily understand. I started
to draw the cartoons in March; after three weeks they were ready
and the business of putting lead thread on the glass started. With
the help of my stepson, the glass was finally finished three weeks
later. When certain technical problems arose, I rang Duchamp in
New York and he answered my questions candidly and most
charmingly. He also said that he would be coming to Stockholm
in September, and that we could finish the part called* The Bride's
Clothes *together at that time.*

He came and we received The Bride's Clothes, *finished by a glazier
from his drawings. He also painted the cones in the lower half with
Verona greenearth and pointed out a few faults. I wanted to correct
them immediately, while he was still in Stockholm, but he said that
there was no hurry – he thought we should socialise and have a
good time instead. 'You can do that after I've gone ... ' I told him I
would carry on – maybe he would be kind enough just to point out
the worst errors? And he answered that it was only a case of minor
details, which were of no importance at all. 'If you think of
something, then just change it' he said. Over the years I discovered
quite a few problems: the copy was rather bad. For instance, the
glass I had got hold of was too green and it was impossible to do
anything about it. When Pontus Hultén was staging an exhibition
in Bonn in 1992, he wanted to borrow the glass. By that time the
glue that had been used to keep the lead threads in place had
become so dry and fragile that all the lead would fall out if the glass
were moved. 'But I can do a new one' I said. And with the help of
two young painters, Henrik Samuelsson and John Stenborg, a new
one was made between October 1991 and April 1992. On that one
almost all the mistakes are corrected. I discovered quite a few that
I had had no idea about – for instance that the perspectival point
of departure of the runners on* The Sleigh *in the lower half is moved
19.5 cm to the left. As far as I know, no one has discovered it.*

(Ulf Linde)

(This article was originally written for the exhibition catalogue at
Moderna Museet, Stockholm, Kunst und Ausstellungshalle der
Bundesrepublik Deutschland, Bonn, 1996)

Duchamp, Marcel
French
1887-1968

Why Not Sneeze, Rose Sélavy?
1921

Replica made 1961 by Ulf Linde
1963, signed by Marcel Duchamp
in Milan 1964. Corrected by
Ulf Linde 1984.

Painted iron, marble, wood,
fishbone, thermometer.
10.5 cm x 16.5 cm x 21 cm

Gift 1965 from Moderna Museet's
Friends Association

This little birdcage is full of sugar lumps... but the sugar lumps are made of marble, one is surprised at how heavy the cage is when it is lifted up. The thermometer is meant for taking the temperature of the marble. Why not sneeze? – as the title is – was made in 1921. Considering it is a readymade, it has certainly been helped along, the cage is not the only one – the sugar lumps had to be sawn out of marbleand the thermometer placed there.

(Marcel Duchamp, from *Apropos de moi-même*, 1964)

When Marcel Duchamp was in Stockholm, he signed the glass, plus a couple of reconstructions that Ultvedt and I had made as early as 1960 – The Bicycle Wheel and Fresh Widow.

In 1963 Boîte en Valise was to be exhibited at Galerie Burén in Stockholm and that is when I got the idea to reconstruct more readymades, which could be exhibited at the same time. I wrote to Duchamp and he agreed that exact replicas of every readymade should be shown. So I engaged a group of artisans to produce replicas from my drawings – except Fountain, the urinal, which was removed from a restaurant in Stockholm – 3 Stoppages étalons, Why Not Sneeze Rose Sélavy?, A bruit sécret, ... pliant... de voyage, Air de Paris, Peigne and The Bottle Rack. Some of them were lent to to the exhibition in Pasadena in the autumn of 1963 where Duchamp signed them. The rest he signed in Milan in 1964. In the same year I looked him up in Paris and told him then that I had already discovered a few faults in them. 'Correct them then!' he laughed. I did – but not until 1977, when I had an opportunity to measure them in detail at the retrospective exhibition in Beaubourg.

That is the story of the replicas in brief. One could possibly add that Air de Paris has disappeared and been replaced by a better replica, which is unsigned, and that Duchamp, for some reason that I cannot remember, never signed The Bottle Rack.

(Ulf Linde)

(Originally written for the exhibition catalogue Moderna Museet, Stockholm, Kunst und Ausstellungshalle der Bundesrepublik Deutschland, Bonn, 1996)

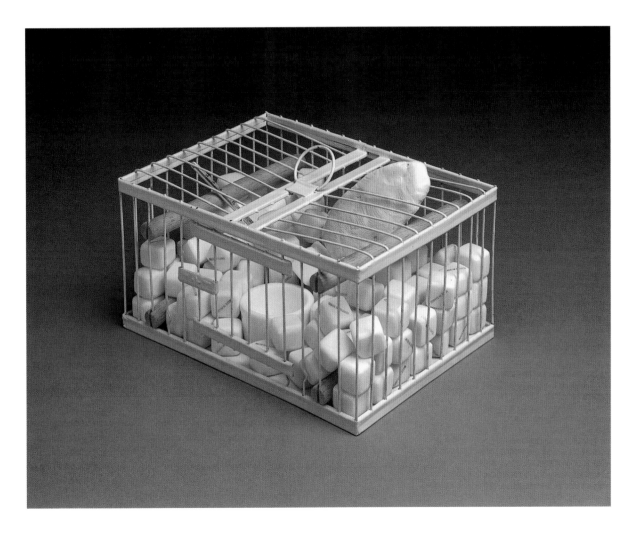

Eggeling, Viking
Swedish
1880-1925

Right:
Symphonie diagonale
Study for Diagonal Symphony
1920

Pencil on paper
51 cm x 213 cm
Gift 1967 from Hans Richter

Below:
Symphonie diagonale
Diagonal Symphony
1924

16 mm, black & white film
16 frames per second, silent
7:40 min
Purchased 1958

During the first years of the 20th
century, Eggeling lived in Germany,
Switzerland and Italy. Around 1911
he moved to Paris where he became
acquainted with, among others,
Modigliani, Arp and Tzara. In 1918,
he was introduced to the Dada Group
in Zurich and became the only Dadaist
of Swedish origin. Following his
untimely death he achieved a reputation
in Berlin as one of the most innovative
artists working in Europe during
the 1920s, through the abstract film
Diagonal Symphony.

Viking Eggeling's work is fired by the idea of introducing time as
a factual dimension in art, and in combination with a 'universal
language' based on abstract forms, of creating a kind of optical
symphony. Several artists at this time – Leopold Survage and
Walther Ruttman for example – were driven by the same ideas,
but Eggeling was, perhaps, the one who best understood the unique
potential of film to realise this new art form. Deeply influenced
by music theory, Eggeling made his methodical sketches in analogy
with music. This sketch for the *Symphonie Diagonale* is one of
the few signed drawings. It was sold to Hjalmar Gabrielsson in
Göteborg in 1922-23 and again, about 40 years later, by
Gabrielsson's stepson Desmond Graham, London, to Galerie
Beyeler in Switzerland. In 1963 the artist Hans Richter, with
whom Eggeling collaborated between 1918 and 1921, bought
the drawing and exhibited it the same year at Yale University Art
Gallery. Later in the 1960s it was donated to Moderna Museet.

In 1922, after a series of setbacks and a controversy with Richter,
Eggeling received a loan from his sister Sara, which enabled him to
obtain a studio with film equipment in Berlin. As early as 1920 he
and Richter had been experimenting with the animation of static,

geometric images, and had made several film sequences. In the studio he continued working on his first film *Horisontal-vertikal orkester* (*Horizontal-Vertical Orchestra*), but never finished it, turning instead to his second film, *Diagonal Symphony*. In the summer of 1923, with the help of Ré Niemeyer, a student at the Bauhaus school in Weimar, he began the time-consuming work of producing film, animating his compositions made of metal foil in single-frame takes. After a little more than a year *Symphonie diagonale* was premiered on 5 November 1924 in front of a private gathering in Berlin. Audience members included Moholy-Nagy and Lissitzky. On 3 May 1925 the film was shown publicly in a cinema at Kurfurstendamm in Berlin. The abstract flow of images can be likened to a musical composition. Luminous, geometric constructions open up and interact on the deep black screen, sometimes appearing from the right, sometimes from the left. A rhythmic transition links each new symphonic layer: angular square shapes, light organic elements moving to a meditative tempo then disappearing into the dark, straight, perpendicular lines, curved forms, complex formations and dotted light reflexes.

(This information is mainly taken from: Louise O'Konor, *Viking Eggeling 1880-1925, Artist and filmmaker, Life and Work*, 1971)

Erixson, Sven
Swedish
1899-1970

Tidsbild
Picture of our Time
1937

Oil on canvas
137 cm x 136 cm
Purchased 1978

During his youth, Erixson studied at
the Art Academy. When he saw the work
of the painter Hilding Linnqvist he was
inspired, asking 'Is one allowed to paint
like this?' Travels to Spain, Yugoslavia,
France followed. Member of the group
Färg och Form. Public commissions
and a professorship at the Art Academy
followed, where he taught, among others,
Rodhe, Pehrson and Lindell. After a serious
illness in the mid-1960s he slowly resumed
painting.

In the mid-1930s the big traffic junction was built at Slussen in
Stockholm. Sven Erixson lived at Urvädersgränd in the district
of Söder, overlooking the building site and the old Katarina lift –
a black skeleton of cast iron. In all weathers, in morning light,
burning sunshine, at dusk and at night, Erixson painted everything
he saw. (With the help of his paintings, it would probably be
possible to reconstruct the entire course of the building works;
he is said to have uttered: 'I have painted the lift so many times
that they could not see any other way out but to pull it down'.)

When in 1934 Erixson moved with his family to Bastugatan, only a
few blocks from Slussen, he continued to follow the transformation
of the place into a miracle of functionalism – a new lift, a pedestrian
bridge with the restaurant Gondolen, a Co-op building and arcades
lined with gigantic windows. At five o'clock, on their way home
from work, people poured through this throbbing heart of glass
and concrete, seeking out the newsbills pasted up on billboards:
blood, war, gossip, sports results. One man (is he strengthened by
what he has just read or is he someone who never reads anything?)
walks stiffly out to the left; those who have read the headline about
an impending war look up at the evening sky; someone ponders;
another despairs. In *Picture of our Time*, Erixson has turned this
scene into a nature painting, as wild as the blotchy evening sky.
Expressionist, naivist or primitivist? These categories become
irrelevant given the timelessness of this work: the characters and
their gestures have always existed and will continue to do so.

Ernst, Max
German
1891-1976

Right:
Figure humaine
Human Figure
1931

Oil and plaster on panel
183 cm x 100 cm
Purchased 1967

Below:
Trois cyprès réciproques
Three Reciprocal Cypresses
1925

Frottage, pencil on paper
25.3 cm x 20 cm
Gift 1994 from Peggy Bonnier

In 1919, Ernst founded the Cologne Dada group together with Hans Arp. He adapted the techniques of collage and photomontage to Surrealist uses, settling in Paris in 1922 and joining the Surrealist movement on its formation in 1924. Over the next years he produced some of the masterpieces of Surrealism – works of hallucinatory intensity created from a symbolic personal mythology stemming from childhood memories. In 1938 he broke with the group, moving to the USA three years later, where he lived until 1948. A major retrospective of his work took place at Moderna Museet in 1991.

In his autobiographical notes of 1963, Max Ernst described 'frottage', which he had invented in the summer of 1925, as 'a technical means of heightening the intellect's hallucinatory ability so that "the visions" automatically appear, a means of liberating oneself from one's blindness'.

Placing a sheet of paper on a wooden floor he would rub it with a pencil to trace the grains in the wood and whatever else happened to be lying there. In this way, a 'drawing' of subconscious images would begin to emerge. The rough surface was subject to chance rather than artistic will – or 'blindness' in Ernst's words. Later, he would consciously retouch or correct the details.

Frottage was particularly appropriate to the Surrealists, who never devoted themselves to empirical nature studies, believing instead that imagination, dream and the subconscious were the pathways to a new vision. Its discovery led Ernst to yet more alternative techniques. *Human Figure* was made on an uneven, rough surface and plaster, the brush struggling randomly among grooves and bumps until the image, resembling a human being with elements of both bird and insect, appeared. All that the conscious hand had to do after that was to make the surreal real.

In images such as these, in which human figures are masked by lines and blots or disguised as birds, insects, or other creatures, Ernst shows us human qualities that we had long since forgotten.

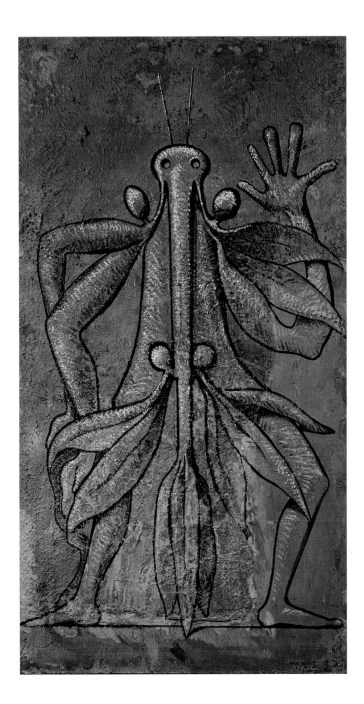

Fahlström, Öyvind
Swedish
1928-1976

Right:
Ade-Ledic-Nander II
1955-57

Oil on canvas
190 cm x 211 cm
Gift 1959 from
Director Theodor Ahrenberg

Below:
Detail of Ade-Ledic-Nander II

Fahlström came to Sweden from São Paulo as an 11-year-old where he remained until he moved to New York in 1961. Referring to himself as 'an author' he has worked both as a journalist and as a poet, publishing in 1950 a manifesto for a concrete poetry that would dispense with the conventional meanings of words. In 1955 his first, serial abstract works were exhibited, followed two years later by the great painting *Ade-Ledic-Nander*. Another major painting, *Dr Schweitzer's last mission Phase II* was executed from 1964-66. Also in the 1960s, Fahlström developed his 'variable' pictures – 'paintings' whose parts can be moved by the spectator like chess pieces. In the 1970s his paintings began to take on a political, journalistic character and he started to make films.

The title is arbitrary; it is the name of a principle or quality that is described in a science-fiction story by Van Vogt. I have used it to point out his tripartite system or universe. Planned as an epic work (about 20 paintings have been prepared in extensive notes – of which only the little 'introductory' I and the big II have been completed), it was to depict the individuals, 'the sign forms', in the three 'clans' or societies: ADE, LEDIC and NANDER.

In II one sees mainly the first of the three 'families' or 'societies': the ADEs – which can be recognised by the vertical form with 'the point aerial stabiliser' on top; its predominantly cool colours (the separate 'clans' are often characterised by combinations of coloured stripes); the black (almost) triangle in their midst with many or few white 'grains' that show the degree of 'well-being and/or powerfulness', which in turn offers or cuts down a number of possibilities; 'the claw-beak' in the lower part of each individual/ sign form ... These and a further five-10 prerequisites-laws-rules of the game make the ADEs live, fight, multiply, collapse, fall ill, subjugate, freeze etc. across the whole painting.

In one place (the black 'smoke' in the painting's lower half) there is, however, an isolated and threatened colony of rounded, reddish, centrally built LEDICs of which one catches up with an ADE (close to the largest whole circle to the right). Most of the other ADEs in the area are read out as 'ghost forms', contours-negatives-forms, since they are not strong-healthy etc. enough to exist on the 'barren' black background.

One of them has, like many ADEs, partly taken possession of a LEDIC as a specially valuable instrument-slave-source of energy – this ADE sees its slave-instrument develop in a terrifying way now that it is near its peers, and in the end it breaks the barriers and gets the upper hand over its former lord and master.

(from Öyvind Fahlström, *Notes about Ade-Ledic-Nander (1955-57) & some later lines of development*, October 1963 quoted in Moderna Museet exhibition catalogue, 1979)

Every Friday night Öyvind used to invite those who wanted to come and look at the progress of the painting. His exhibition technique was very special. He had cut holes in a sheet which he had hung in front of the painting and he only spoke about and described the section which could be viewed through the hole. This was so that the spectator would not be distracted by other sections

of the painting and not be seduced by aesthetic concessions like, for instance, admiring the composition in its entirety. He claimed that he kept the sheet there when he painted as well so as to stop himself from making compositional concessions at the expense of the contents.

(from Pontus Hultén: Öyvind Fahlström, världsmedborgaren (*The World Citizen*), August 1979, in the Modern Museum exhibition catalogue, 1979.)

Fautrier, Jean
French
1898-1964

Right:
Grande tête tragique
Large Tragic Head
1942

Bronze
H 33 cm
Gift 1966 from Moderna
Museet's Friends Association

Below:
Tête multiple
Multiple Heads (from the series
Hostages) 1944-45

Mixed media on paper
32 cm x 40 cm
Purchased 1966

Born in Paris, Fautrier moved to London
in 1909 and studied at the Royal Academy
and Slade Schools He returned to France
in 1917 where he began to make realistic
paintings in the spirit of Derain. In 1941,
under suspicion from the Gestapo, Fautrier
moved to a house outside the city (which
later turned out to be a place of execution
for prisoners of war), where he lived for
the rest of his life. The series of paintings
Otages (*Hostages*), were begun in 1942,
inspired by the horror of war. Fautrier
executed these works on paper covered
with a thin distemper, building up layer
upon layer of thick white paint, often in
the shape of an oval/head, which he later
painted over with several colour washes.
Attracting great admiration from Jean
Dubuffet, they were described by post-war
critics as early examples of 'Art Informel' –
'informal' or 'other' – a label both artists
rejected vehemently.

*Fautrier made this sculpture in 1942, the same year he made the
series of paintings, Otages. Did the paintings inspire the sculpture,
or was it the other way around?*

*Apart from the fact that a portion of the face is missing, this
sculpture is considerably more realistic than the eyeless Otages.
If one assumes that Fautrier was developing away from realism
during 1942, it would also be reasonable to assume that the head
preceded the famous paintings, and that the torn-off cheek
therefore represents the birth of* art informel ...

*... What happens when he turns his back on compulsion, or habit
and accepts the effects of the disfigurement as a more valid 'form'
than the one he has been working with up to then? Why does he
choose the rough, unintentionally produced clay surface before the
realistically sculpted eye? Which factors played a part? What
happens to him?*

(from Ulf Linde's catalogue article for the exhibition *Hommage à
Jean Fautrier*, Svensk-Franska Konstgalleriet (Swedish-French Art
Gallery), Stockholm 1966.)

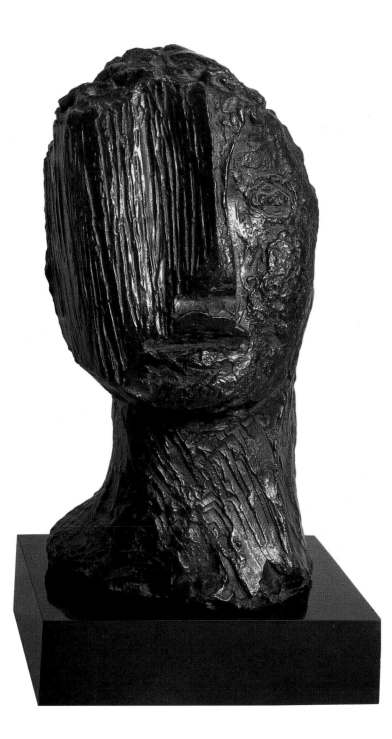

69

Fenton, Roger
British
1819-1869

Field Kitchen of the 8th
Hussars, The Crimea
1855

Saltpaper photograph
15.6 cm x 19.8 cm
Purchased 1964

Parallel with his academic training as a
lawyer, Fenton took courses in drawing
and painting. After a period in Paris, Fenton
moved back to London and continued
working on his historical paintings, which
he exhibited three years running in the
annual exhibitions at the Royal Academy.
He was a founder of the North London
School of Drawing and Modelling before
turning his attention to photography.

Towards the end of the 1840s Roger Fenton began to develop
an interest in photography. He had learnt Le Gray's method with
waxed paper negatives and started to practise it himself. During
the autumn of 1852 he went to Russia and produced stereo
negatives on paper of pictures taken in Moscow and Kiev using
a large camera. Many experiments were needed at each separate
exposure and after each the camera was moved sideways according
to a special scheme in order to achieve a three-dimensional effect.
In December of the same year Fenton exhibited 38 photographs-
three of which were taken in Russia- at the first public exhibition
of photography in Great Britain.

Fenton had previously photographed the departure of the British
Navy to the Crimea at the request of Prince Albert. On the Prince's
recommendation Fenton was himself appointed to go to the
peninsula in the Black Sea in 1855 in order to photograph the
British troops and their allies in the war between Turkey and
Russia, where France and England were fighting on the side of
the Turks. The pictures that he took there are often called the
first war reports but this is misleading since he never depicted any
actual battles. Instead he concentrated on military environments
and people, plus a number of surveys of military camps and
formations of troops in the landscape.

The method he used for these works – wet collodion – called for
immediate development in order to preserve the light sensitivity of
the material. To do this he brought along a horse-drawn wine cart,
which he had rebuilt himself as a dark room on wheels. The large
exposed and developed glass-negatives were sent to London where
they were turned into positive saltpaper prints or the slightly more
modern albumen-silver prints. The Modern Museet Collection
holds no less than 147 of Fenton's photographs from the Crimean
war, produced on both types of paper.

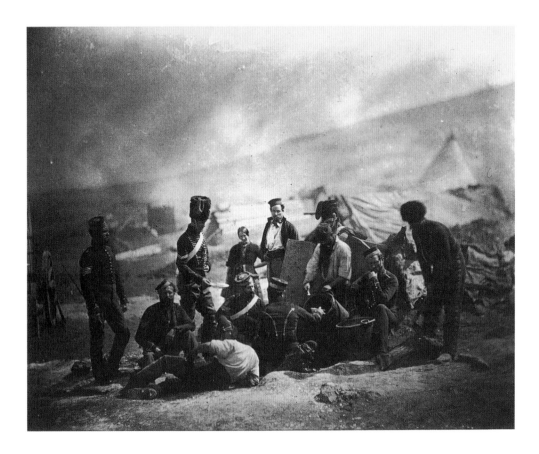

Giacometti, Alberto
Swiss
1901-1966

Cage
1930-31

Wood
49 cm x 26.5 cm x 26.5 cm
Purchased 1964

The son of a post-Impressionist painter,
Giacometti went to Paris in 1922, where
he studied with Bourdelle. Cubist attempts
followed and in 1930 he became a member
of the Surrealist group, only to split with
them five years later. He returned to
painting and sculpting from life, attempting
to represent reality without the traditional
conventions of perception. A preoccupation
with the concept of distance in relation
to 'absolute size' resulted in the elongated,
skeletal figures for which he is best known.

Few other artists have expressed the degree of agony suffered by
Giacometti in his attempt to understand how the world really
looks. In conversations and interviews he consistently reiterated
the difficulty of 'retaining' the subject. In a letter written in 1947
to his New York art dealer, Pierre Matisse, Giacometti described
how, during a few years at the beginning of the 1930s, he had
found a temporary solution. Influenced by, among others, André
Breton, he made sculptures as dream visions instructed by his inner
self, of which he claimed he could not understand the meaning:

> Since I wanted nevertheless to realize a little of what I
> saw, I began at last to work at home from memory.
> I tried to do what I could to avoid this catastrophe.
> This yielded, after many attempts touching on Cubism ...
> in objects which were for me the closest I could come to
> my vision of reality.
>
> This gave me some part of my vision of reality but I still
> lacked a sense of the whole, a structure, also a sharpness
> that I saw, a kind of skeleton in space.
>
> Figures were never for me a compact mass but like a
> transparent construction.
>
> Again, after making all kinds of attempts I made cages
> with open construction inside executed in wood by a a
> carpenter.
>
> ... The nearest I could get to... a spoon shape for a
> woman, a bobbin for a man, two spheres for their heads,
> a fork for the spine.

Giacometti quoted in Reinhold Hohl, *Albert Giacometti,*
1972

Gonzalez, Julio
Spanish
1876-1942

Femme se coiffant
Woman Combing her Hair
c 1934

Iron
121 cm x 60 cm x 29 cm
Purchased 1967

Born into a family of metal workers,
Gonzalez learnt the techniques of that trade
in his early years. However, he wanted to
become a painter and following his studies
in Barcelona, went to Paris in 1900 where
he became a member of Picasso's circle.
It was not until 1917 that he turned to
sculpture, working mainly in wrought and
welded iron. A pioneer in this field he 'drew
in space', creating bodies or parts of the
body in iron plate or iron thread. Some of
his works were Cubist in style, reflecting
Picasso's influence, but it was Gonzalez
who taught Picasso the traditional Spanish
techniques of metal work.

Designing and drawing in space with new means, utilising it and moulding it as if it were a novel material, that is what I am pursuing. Only the spire of a cathedral can show us that point in Heaven, where our soul may live.

In the unrest of the night the stars are to us points of hope in the skies. These points in infinity have been the forerunners of the new art: Signs in space.

The significance of the problem to be solved is not merely the creation of a harmonic work, a fully balanced whole, No! Its solution lies in the union of matter and space, of realistic and imaginary forms, denoted by fixed points or holes. These forms must flow into each other and must be inseparable like body and soul.

The synthetic transformations of material forms, of colours, light, piercings, the absence of compact planes, convey to the work of art a mysterious, fantastic, indeed a diabolical aspect. In transposing the natural forms and infusing a new spirit into them, the artist works with deifying space.

Centuries ago the Iron Age began, unfortunately, to create arms, among which some were even beautiful, Today it enables us to build bridges, factories, railways ...

It is high time that this material stops being murderous or being merely subservient to a mechanised science: the gate has now been opened wide so that it may penetrate into the Realm of Art, to be hammered and moulded by the peaceful hands of the artist.

(Notes by the artist, published in *Julio Gonzalez*,
Galerie de France, Paris 1959)

Gris, Juan
Spanish
1887-1927

Le compotier sur le tapis bleu
Fruit Bowl on a Blue Cloth
1916

Oil on canvas
50 cm x 61 cm
Gift by bequest 1989
from Gerard Bonnier

After a few years' study in Madrid Gris
arrived in Paris in 1906, renting a studio
in the Bateau-Lavoir in Montmartre where
Picasso was one of his neighbours. He
supported himself, like other young
painters, by sending drawings to the
'boulevard papiers', above all to *L'Assiette
au Beurre*. In 1911 he was producing grey
Cubist paintings (the name Gris, grey in
French, was assumed), and in 1912 he
began to show his work with the Cubist
group Section d'Or. The same year the art
dealer Daniel-Henri Kahnweiler, who later
became a great friend, made an exclusive
contract on his work. Creating his own
form of Cubism based on the *papiers
collés* of Picasso and Braque he earned
the title 'the mystic of Cubism' from the
critic Maurice Raynal.

During the war years 1914-18 there were almost no exhibitions.
It was not until the spring of 1918 that Léonce Rosenberg opened
his gallery L'Effort Moderne, and it was there that, in 1919, Gris
exhibited his paintings from the previous three years. In a letter
to the friend and art dealer Kahnweiler the artist gave his view of
artistic life in Paris and of his own art:

> There were about 50 pictures, painted in 1916, '17 and
> '18. They looked rather well as a group and a lot of
> people came. Yet I don't really know how much they liked
> it, for there is so much admiration for the sheerest
> mediocrity; people get quite excited about displays of
> chaos, but no one likes discipline and clarity. The
> exaggerations of the Dada movement and others like
> Picabia make us look classical, though I can't say I mind
> about that. I would like to continue the tradition of
> painting with plastic means while bringing to it a new
> aesthetic based on the intellect. I think one can quite well
> take over Chardin's means without taking over either the
> appearance of his pictures or his conception of reality.
> Those who believe in abstract painting seem to me like
> weavers who think they can produce a material with
> threads running in one direction only and nothing to hold
> them together. When you have no plastic intention how
> can you control and make sense of your representational
> liberties? And when you are not concerned with reality
> how can you control and make sense of your plastic
> liberties?

> For some time I have been rather pleased with my own
> work because I think that at last I am entering on a period
> of realisation ... I have also managed to rid my painting of
> a too brutal and descriptive reality. It has, so to speak,
> become more poetic. I hope that ultimately I shall be able
> to express very precisely, and by means of pure intellectual
> elements, an imaginary reality. This really amounts to a
> sort of painting which is inaccurate but precise, just the
> opposite of bad painting which is accurate but not precise.

(Letters of Juan Gris, edited and translated by
Douglas Cooper, 1956.)

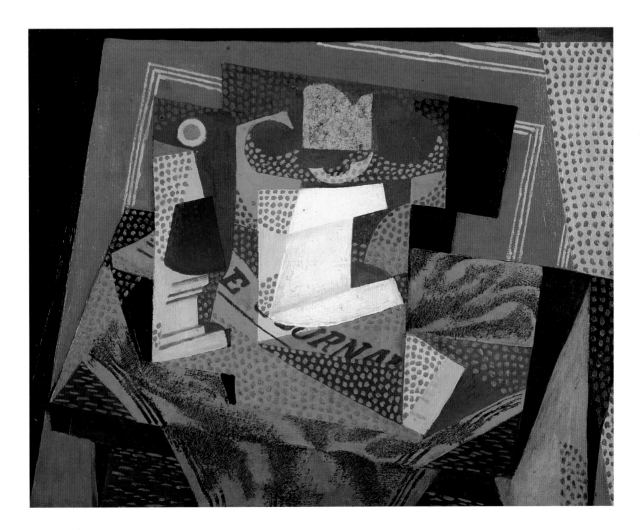

Hjorth, Bror
Swedish
1894-1968

Kubistisk flicka
Cubist Girl
1921

Bronze
H 156 cm
Purchased 1971

From 1914, Hjorth studied in Uppsala before
contracting tuberculosis, which lasted for
four years. He then went on to the Art
Academy in Copenhagen, before moving
to Paris in 1921 where he studied with
Bourdelle at the same time as Giacometti.
Returning to Sweden in 1930 he became
one of the initiators of the group Färg och
Form (Colour and Form). Professor in
drawing at the Art Academy in Stockholm.
In 1967 he published his autobiography *Mitt
liv i konsten (My life in art)*.

*In the summer of 1921 I rented a studio in Clamart, one of the
suburbs of Paris and quite close to Rodin's old studio in Meudon.
... Clamart is a lovely little town. A short distance from the studio
was an idyllic little restaurant with a garden where I had my meals
and sat alone most of the time.*

*The evenings were spent in Montparnasse like before. It was not a
practical summer abode, but useful, because I could philosophise
undisturbed about art and how to get rid of unfortunate stylisation.
I stopped going to Bourdelle for a while. I started with Cubism
and tried methodically to create volume. I experimented. My figures
became more massive, heavier. I broke up the whole into primary
ingredients, and joined them together again. Each ingredient had to
be a volume by itself with its special character, a volume with three
dimensions. They should be joined to a rhythmic whole that would
express the greatest force, and become a powerful edifice, as if built
with bricks of different shapes and appearances, firm and close to
earth. And I learnt to understand that it was the inner form that
mattered, which gave it character. I wanted to achieve as much life
as possible. The sculpture had to be built up with sensitivity to the
special character of an object, each part of the human body.
Because from our own body we get the explanation of each form,
the expression in the eyes and hands, the flexing of the hands, the
grasp of the fingers, the movement of the feet when walking and
standing, the function of the various limbs in the body and not the
outer shell. Sensitivity is how to appreciate this correctly, different
weights and characters and movements. It is not to be confused
with feeling, which is a pipedream. It is a question of finding the
laws of art, where the vertical line and the horizontal line create
the first natural right angle in the three- dimensional cube. The
importance of the law of gravity in connection with everything on
our earth, not least art, started to dawn on me.*

In Clamart I modelled a statue in clay. I called it Cubist Girl *and
tried, in non-naturalistic forms, to express the girl's character. I had
a model and I thought I had succeeded well. Gösta Adrian Nilsson
who had heard rumours about it visited me one day and said in a
condescending way: 'You seem to suggest that the girl looks like
that'. I was ashamed to admit that I actually did. It was my own
private Cubism and it had no claims to be included in finer company.
But I am still very happy about it. It is my qualifying piece of work
and it belongs to the few things that I am completely happy with.*

(From the artists' autobiography, *My life in Art* 1967).

Jonsson, Sune
Swedish
b 1930

Småbrukarparet Albert och
Tea Johansson
The Farmers Albert and
Tea Johansson
c 1955

Gelatin silverprint photograph
31 cm x 40.1 cm
Purchased 1964

Jonsson grew up in the Västerbotten
province and studied in Uppsala and
Stockholm. His interest in photography
started during his school years and was
further developed through the Photographic
Society. Together with Beata Bergstrom,
Rune Jonsson, Ivar Björnberg, Konny
Domnauer, Pär Frank and Ove Wallin he
formed the group *Seven Stockholmers.*
Wishing to popularise the art of
photography, they adopted the slogan
'Photography for the people'.

Sune Jonsson is a photographer with a feeling for the specifically Swedish as found in people and places in the sparsely populated parts of the countryside. It is in black and white that his unerring feeling for the forms of the landscape, for working tools and the flight of the shadows of clouds across flat fields is best realised. Inspired by a group of American photographers who had taken part in a documentary project organised by the American government during the 1930s as part of President Roosevelt's New Deal programme that depicted the lives of smallholders and leaseholders in southwestern USA, he depicts the vanished, agrarian Sweden, the rural landscape and the dependence on the seasons. The pictorial style that Jonsson has made his own is also indebted to photographers like Roy DeCarava and Eugene Smith.

In a series of books Jonsson has described the lives of less fortunate people both in pictures and words. His work as a field ethnologist at Västernorrland's Regional Museum has helped him to continue his observations.

Judd, Donald
American
1928-1994

Untitled
1965

Galvanised sheet iron
7 boxes, each box:
23 cm x 102 cm x 76.5 cm
Purchased 1966

After academic studies in Philosophy and
Art History Judd started to write critical
articles about the art that he considered
obsolete: 'the legacy of the Modernists'.
Opposed to all forms of illusionism and
Expressionism he advocated an 'objective'
sculpture of simple 'specific objects', which
manifested itself in his, pure, Minimalist
sculptures of the 1960s.

Somewhat new work is usually described with the words that have been used to describe old work. These words have to be discarded as too particular to the earlier work or they have to be given new definitions. Occasionally new terms have to be invented. I discarded 'order' and 'structure'. Both words imply that something is formed. Material, area, volume, space or colour are ordered or structured. The separation of means and structure – the world and order – is one of the main aspects of European or Western art and also of most older, reputedly civilised art. It's the sense of order of Thomist Christianity and of rationalistic philosophy which developed from it. Order underlies, overlies, is within, above, below or beyond everything.

I wanted work that didn't involve incredible assumptions about everything. I couldn't begin to think about the order of the universe or the nature of American society. I didn't want work that was general or universal in the usual sense. I didn't want it to claim too much. Obviously, the means and the structure couldn't be separate and couldn't even be thought of as two things joined. Neither word meant anything.

A shape, a volume, a colour, a surface is something itself. It shouldn't be concealed as part of a fairly different whole. The shapes and materials shouldn't be altered by their context. One of the four boxes in a row, any single thing or such a series, is local order, just an arrangement, barely order at all. The series is mine, someone's, and clearly not some larger order. It has nothing to do with either order or disorder in general. Both are matters of fact. The series of four or six doesn't change the galvanised iron or steel or whatever the boxes are made of.

(Donald Judd: *Dictionary of Contemporary Artists*, London, New York 1977)

Kandinsky, Wassily
Russian
1866-1944

Improvisation Nr 2, Trauermarsch
Improvisation No 2, Funeral March
1908

Oil on canvas
94 cm x 130 cm
Purchased 1933

Born in Russia and originally an
anthropologist. Kandinsky decided to move
to Munich and take up art. His early works
reflected the content and imagery of
Russian Fairy Tales and then used a
fragmented technique that he had learnt
from the Impressionists. Eventually these
lost their realistic content, and around 1910
he made his first abstract paintings. He was
a member of *Der Blaue Reiter* (The Blue
Rider Group) along with Jawlensky, Marc,
Macke, Klee, Münther and Werefkin and
contributed to their exhibitions and
publications. He visited Stockholm in the
winter of 1915-16 and wrote the article
"Om konstnären" ("About the artist")
published in Swedish the same year.
After the outbreak of the First World War
he returned to Russia where he stayed until
1922, when he went back to Germany to
take up a teaching post at the Bauhaus
in Dessau. When Walter Gropius's famous
school closed, Kandinsky went to Paris
where he spent the rest of his life

*The artist must have something to say, for mastery over
form is not his goal but rather the adapting of form to
its inner meaning.*

*Naturally this does not mean that the artist is to instill
forcibly into his work some deliberate meaning. As has
been said the generation of a work of art is a mystery.
So long as artistry exists there is no need of theory or
logic to direct the painter's action. The inner voice of
the soul tells him what form he needs, whether inside
or outside nature. Every artist knows, who works with
feeling, how suddenly the right form flashes upon him.
Böcklin said that a true work of art must be like an
inspiration; that actual painting composition, etc, are
not the steps by which the artist reaches self-expression.*

The above quotation appears as a footnote in Kandinsky's
Concerning the Spiritual in Art (written in 1909, but not published
until 1911). The concluding paragraphs of the book contain his
definition of *Improvisations*, 'as a rule, unconscious, often sudden
expressions of an inner course of events, i.e. impressions of the
"inner nature" in contrast to, for instance, direct impressions
of the "outer nature", which have been expressed in a painterly
form'. Kandinsky made 35 *Improvisations*; this one, he also called
Picture with Approaching Rider.

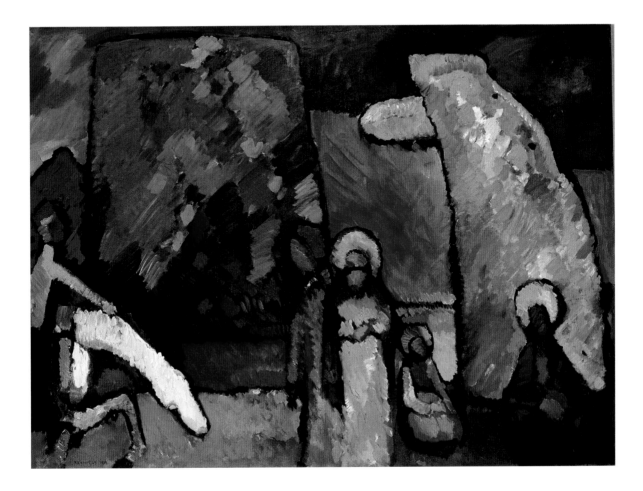

Kienholz, Edward
American
1927-1994

Right:
The State Hospital
1966

Two hard plastic figures,
hospital beds, bed-pans,
hospital table, goldfish bowls,
two live fishes 'Black Mang's',
neon, wood, colour
244 cm x 366 cm x 294 cm
Purchased 1971

Below:
Metal plate of The State Hospital

Based in Los Angeles during the 1950s
and 60s, Kienholz made a series of tableaux
that criticised the double standards and
hypocrisy of American social institutions.

THE STATE HOSPITAL, KIENHOLZ 1964–1967

This is a tableau about an old man who is a patient in a state
mental hospital. He is tied with leather straps around his wrists
to a bed in a bare room. (The tableau must include a real hospital
room with walls, ceiling, floor, a door with grids etc.) There is
only a bed-pan and a hospital table (just out of reach). The man
is naked. He is in pain. He has been hit in the stomach with a bar
of soap, wrapped in a towel (to avoid causing revealing bruises).
His head consists of an illuminated and water-filled glass bowl,
containing two live black fishes. He lies very still, on his side.
There is no sound in the room.

Above the old man there is an exact copy of him, including the
bed (the beds are on top of each other like bunk beds). The upper
figure also has a fishbowl head, two black fishes etc. But in addition
it must be enclosed in some sort of plastic bubble (maybe something
similar to a balloon). It contains the old man's thoughts. His mind
cannot imagine anything beyond the present. He is doomed to stay
here for the rest of his life.

Price:	Part one	$15.000.00
	Part two	$ 1.000.00
	Part three	Expenses plus the artist's salary

(Text accompanying the artist's installation.)

Printed in the catalogue was a photograph taken during the period
in which he was working on the tableau and a text that ran as
follows: 'The scene can be traced back to experiences at a mental
hospital where Kienholz worked in 1948. Kienholz was horrified
by what he saw of sadistic guards, indifferent doctors and the
tyrannical and inhuman treatment of patients, and he constructed
his hospital afterwards as a bitter accusation against all such
institutions.' The 'patient' is a plaster cast of an emaciated,
severely ill man – one of Kienholz' friends.

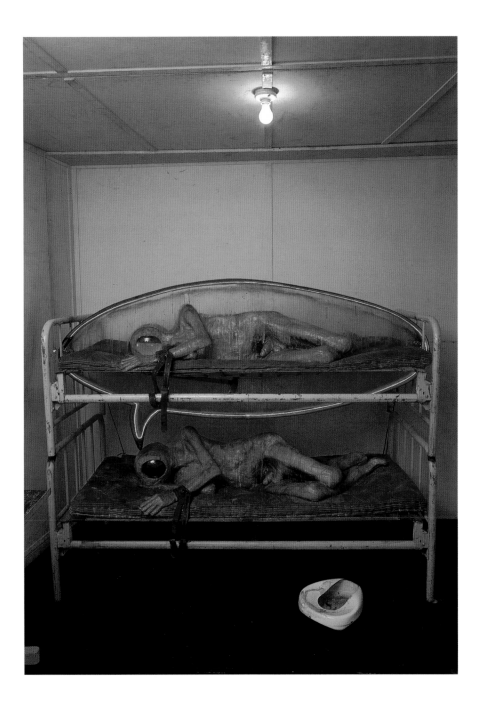

Kirchner, Ernst Ludwig
German
1880-1938

Right:
Marzella
1909-10

Oil on canvas
76 cm x 60 cm
Purchased 1967

Below:
Kirchner's painted drapery in
the Brücke painters' studio
1910

Early on in his career, Kirchner discovered
the engravings and woodcuts of Albrecht
Dürer and the abrupt angularity of these
works became characteristic of the style
advocated by the Brücke (Bridge) group,
which he founded along with Heckel and
Schmidt-Rottluff in Dresden in 1905. His
'programme' could apply to the whole
group: 'simple, great form and clear
colours, to feel and experience'. In 1912-13
in Berlin he created a series of street
scenes that are considered to represent
the most typical form of German
Expressionism.

The Moderna Museet's collection contains relatively few works
of German Expressionism and although, up until 1914, Swedish
artists, collectors and museums came into close contact with
German artists, few of their works were purchased. When this
painting by Kirchner – acknowledged by many to be amongst his
most important works – was acquired as late as 1967, it provided
Stockholm with a much-needed opportunity to view the best of
German Expressionism.

The Brücke painter's studio at Berlinerstrasse 65 in Dresden in
which Kirchner lived during the years 1908-11 was furnished with
carved stools and tables, sagging divans and cushions. The walls
were covered with drapery painted in the 'primitive' style. In a
doorway hung a yellow curtain decorated by Kirchner with loving
couples. The erotic atmosphere was unmistakable.

During 1910, Kirchner made several paintings of Marzella and her
younger sister, daughters of an artist's widow. When this work was
made Marzella was about thirteen years of age – thin and girlish,
she still has the body of a child but her manner is coquettish. The
starched ribbon in her hair emphasises her precarious innocence.

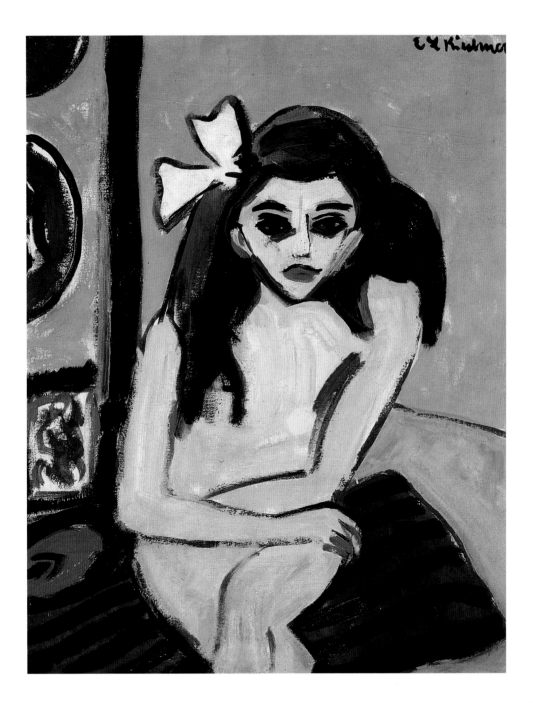

Klee, Paul
Swiss
1879-1940

Tiermonument
Animal Monument
1938

Oil on canvas
86.5 cm x 54.5 cm
Purchased 1949

In early life Klee was torn between becoming a musician or a painter and his later involvement with Kandinsky and the Expressionistic group Der Blaue Reiter reflects his interest in the relationship between colour and tone, line and rhythm in art and music. In 1914 he visited Kairuan in Tunisia with Auguste Macke and 'discovered colour'. This was to be the source of some of his most characteristic abstractions, which combined great technical proficiency with a fertile inventiveness. From 1921-31 he taught at the Bauhaus, taking up a post at the Düsseldorf Academy until he was forced to abandon it in 1933 by the Nazi administration.

Throughout his career, Klee experimented with dozens of different styles. Late in life, tormented by an incurable disease and exiled from Germany where he had worked for most of his life, he searched for new methods to make his work easier. Feeling that there was no longer time for elaborate details he abandoned his previous laborious techniques for a new 'style' that would prove to be his last.

Working rapidly in black paint applied in rough strokes with a broad brush he developed a form of 'sign painting' as brief and poetic as ancient runes or 'secret signs' as he called them.

In this work the outline of a feline animal was painted on coarse, untreated jute cloth after which the background was filled in with a paste-like distemper. Rudimentary marks provide the creature's pointed ears, hole-like eyes, whiskers paw and claws.

The title, *Tiermonument (Animal monument)*, was typical of Klee who had invented words since childhood; its dark spirit reflects the harsh political realities of the times in which it was made.

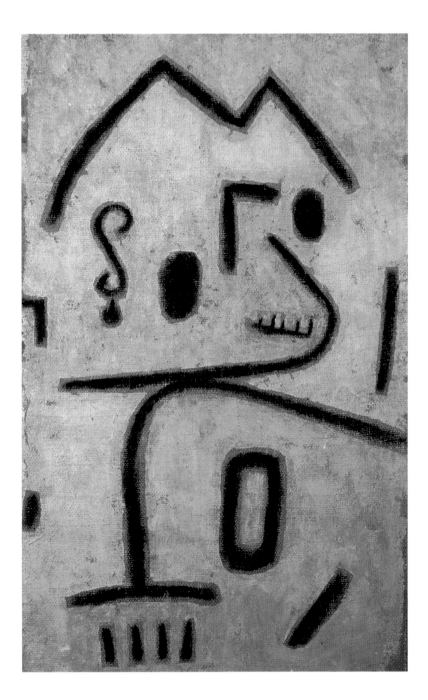

Kylberg, Carl
Swedish
1878-1952

Uppbrottet
The Departure
1935

Oil on canvas
106 cm x 124 cm
Gift 1937 from
Tora Teje-Sylwander

Kylberg began his career by studying architecture but later turned his attentions to Fine Art. He was greatly interested in the paintings of Cézanne but in contrast to several of his contemporaries who developed the ideas of the Master of Aix into non-figurative, Cubist works, Kylberg studied these works in order to 'become a classicist again'. His notes, *Ur ett livs dagbok*, (*From A Diary of a Lifetime*), were published posthumously in 1959.

Uppbrottet (Departure)
I saw the Wise Virgin with her lamp under nightly green trees and in the light from the lamp I saw the child of sorrow and doubt. I saw them ready to break up in order to follow the virgin and maybe each find their own faith in her aura. That is why I have called the painting The Departure, *the only process in the world of human beings.*

(From *A Diary of a Lifetime*)

... The form reveals more, if it does not try to say too much itself. When I paint something, I try to ignore the inessential exterior in order to grasp the ideas behind it. Of course one can copy a tree so that it does not leave anything to be desired in realism. But does not that work become more of a copy then, routine rather than art? ... I try to convey the idea of the tree in its relation to a greater whole, its tone, its essence, its special message. I do not paint the inessential exterior forms, but the tree. The details fall away, the forms sink into the background to give place to this other thing that I consider more important.

(from Brita Knyphausen, *Carl Kylberg*, 1965)

When the Swedish National Museum made a request to Minister Arthur Engberg in the 1930s to purchase this painting he rejected the museum's application, expressing misgivings about Kylberg's 'deficient feeling for form' and the 'whole effect of such a strange picture with its unclear motif and imperfect execution'. The work was only acquired when a famous actress bought it and donated it to the museum.

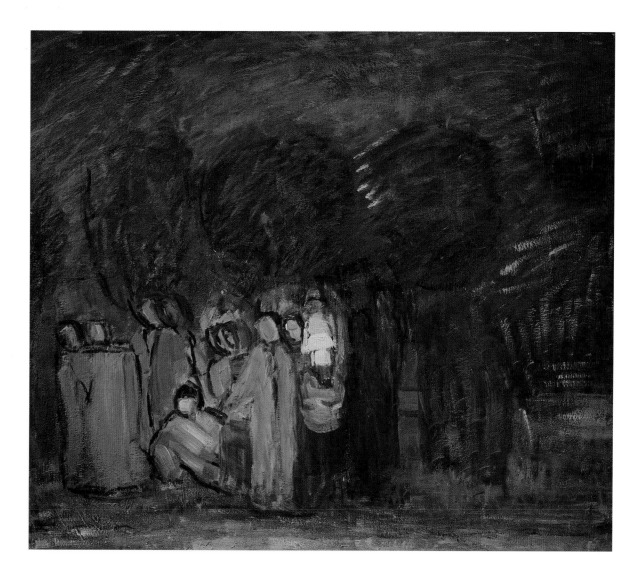

Laurens, Henri
French
1885-1954

Right:
Le clown
The Clown
1915

Painted wood
53 cm x 29.5 cm x 23.5 cm
Purchased 1964

Below:
Georges Braque's
Still Life with Violin
1911

Born in Paris, Laurens trained as a stone mason but moved to Montmartre and took up sculpture in 1902. Initially influenced by Rodin he developed a more formalised style that prefigured some aspects of Cubism, a movement that he embraced when he encountered Braque, Picasso, Léger and Gris. Though he applied their ideas to sculptural forms and to polychrome constructions, collages and montages his work remained individual.

Although *The Clown* was made when Laurens was almost 30, it can still be seen as a relatively early work in the development of the sculptor's individual language. It was not until 1911, when he first met Braque, that Laurens began to find his voice.

An example of what he might have seen in Braque's studio at that time is the analytic Cubic work *Still Life with a Violin* with its isolated but expressive fragments of real objects scattered across the canvas. Under the influence of works such as these Laurens entered into a world of form whose potential encouraged him to experiment with the construction, rather than the imitation of nature.

By 1914 Laurens was working on his curvilinear Cubist sculptures, which he called 'constructions', more severe in form but more playful in spirit than his teacher's prototypes had been. The work gives the impression that Laurens, like a juggler, conjured with all the characteristics of a clown – the lazily dangling arms and legs, the melancholy head, the striped costume – until the different parts fell into place and the sculpture found its own form. From this point of view the work could be interpreted as a self portrait: after a serious illness Laurens had undergone many operations including the amputation of a leg; 'I am dismantled into small pieces' he said to his friends.

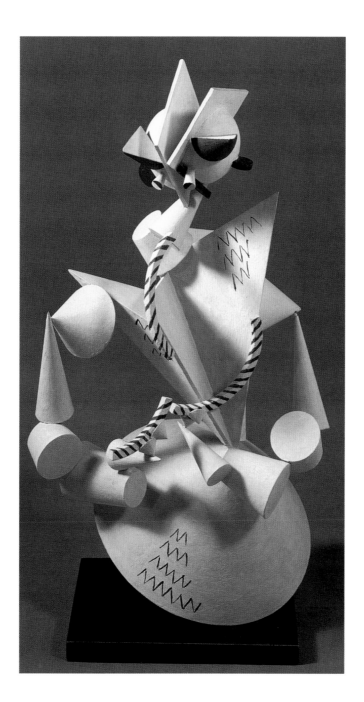

Léger, Fernand
French
1881–1955

L'escalier
The Staircase
1914

Oil on canvas
144.5 cm x 93.5 cm
Purchased 1950

One of the first Cubists to experiment with non-figurative abstraction, Léger has sometimes been referred to as a 'tubist' since the forms in his paintings are more like tubes than cubes. After 1918 he began to associate with members of the Purist movement and developed their 'machine aesthetic' with precise, static, polished works celebrating and representing machinery. During the 1920s and he was employed by Rolf de Maré at the Swedish Ballet, designing sets and costumes. He also worked in cinema, making his own film, *Ballet mécanique*, the first film without a scenario. For many years he worked as a teacher; Otto G. Carlsund and some of the future members of the Halmstad group were among his Swedish pupils. During the Second World War he lived in the USA.

'Contrast of forms' was Léger's term for the paintings he made in 1913-14, believing it was possible to achieve a richly varied composition using the three contrasting forms of cone, cylinder and cube.

In this depiction of a figures descending a staircase, a large cone represents the torso, smaller ones stand for the arms and legs, a cylinder indicates the banister and the right angles of a cube suggest the stairs. By way of these geometrical forms Léger describes the body in the simplest possible manner. As a Cubist he was interested in evoking a sense of volume and this he achieves through the reflections in the metallic shining forms. With a handful of richly contrasting colours – white, black, red, yellow and blue – the expression is further heightened. Léger pours the colours into the drawn contours like a metal-caster filling a mould with red-hot substances.

The Staircase was probably among the last works executed by Léger before he was mobilised in August 1914. That year he wrote down the formula for his art: "contrast=dissonances, in other words the maximal expression".

Linnqvist, Hilding
Swedish
1891–1984

Sjukhussal II
Hospital Ward II
1920

Oil on canvas
145 cm x 122 cm
Gift 1970 from Grace and
Philip Sandblom

Linnqvist was accepted at the Art Academy
in 1910 but like his friends Axel Nilsson,
Fritiof Schüldt and Alf Munthe, was
disappointed with the old-fashioned
teaching methods there. Together they
left the school, renting a studio and hiring
their own models. An admirer of Cézanne,
Munch, Josephson and Courbet. Linnqvist
was a member of the group *Färg och Form*
(Colour and Form). He has been involved
in many large-scale public commissions,
several involving the use of textiles.

Linnqvist's style during the years toward the end of 1910s and the beginning of the 1920s is primitive, but at the same time refined. Primitive in its unaffected sincerity, its alienation from every kind of sloppy or conventional technique, in its indifference to correct perspective and academic drawing, its sometimes coarse and blunt form, but more refined in colour and treatment, the enamel-like liquid quality of the material, the changing scale of dark and light, warm and cold tones and also in the tentative sensitivity of line. The technique is as primitive as the mode of expression. The facture is sometimes brushy and shiny like enamel; the brush either stipples the surface or smoothes it; dark areas are refracted by light streaks, but the dark tone is predominant. There is an intensely pictorial style about the whole thing, very different from the billowing linear patterns of the decorative Expressionists. The primitive feature is also noticeable in the desire to show as much as possible of each object, to copy even the bowls on a table from a bird's-eye view.

(Erik Blomberg, *Hilding Linnqvist*, 1934)

A serious bout of meningitis forced Linnqvist to spend some time in Sabbatsberg Hospital. This painting is, in other words, a picture from memory. Erik Blomberg has also said of this work: "… the big blue windows intensify the silence of the hospital ward, filling it with a smell of carbolic instead of light." And it is true that there is no source of light: outside the windows the blue Stockholm summer night prevails; indoors there are no lamps. The light emanates from all the white objects, disinfected with carbolic: the doctors' coats, the bedsheets, the tiled stoves.

Lundquist, Evert
Swedish
1904-1994

Vågen
The Wave
1942-43

Oil on canvas
115 cm x 104 cm
Purchased 1944

In 1924, when Lundquist was a student at
Carl Wilhelmson's Art School in Stockholm
he made his first trip to France. Here
he obtained a thorough grounding in the
classical tradition of Chardin, Daumier,
Corot and Ingres. In the autumn of the
same year he was accepted at the
Stockholm Art Academy. During the 1930s
he experimented with works that combined
a classical sense of form with emotional
expression. After a few years of crisis he
made his breakthrough in 1941, painting
with a heavy impasto in rich, expressive
colours, imparting a luminous, glowing
quality to his dynamic forms.

In the winter of 1942 Evert Lundquist moved into a studio in Olle
Nyman's family home Övre Gården in Saltsjö-Duvnäs just outside
Stockholm:

> *At the beautiful manor there was a shed for carriages with*
> *a little tower ... and there, among all the old carriages I*
> *was able to stand painting under a protecting roof. It was*
> *there that I made a painting called Vågen (The Wave)*
> *which is a picture of a big wave rolling in. It was finally*
> *bought by Nationalmuseum and is now at Moderna Museet.*
> *This picture was quite unlike the Vågen that I did in 1940*
> *in my attic studio in Tegnérgatan. It symbolises a lot of*
> *that feeling of spring that I felt then, both in nature and in*
> *my new life. It is also the introduction to the next 10 years*
> *in these beautiful old rooms in this wonderful house in the*
> *middle of generous scenery.*
> *... Previously, my form had been strict and almost*
> *approached a monumental and decorative structure. Now*
> *it assumed a greater mobility, an increased Lightness and*
> *maybe also a more direct experience of nature.*

(from Evert Lundquist, *Ur ett målarliv*, (*A Life in
Painting*), 1984)

Magritte, René
Belgian
1898-1967

Le modèle rouge
The Red Model
1935

Oil on canvas
72 cm x 48.5 cm
Purchased 1967

Taking as a model de Chirico's metaphysical art, Magritte made his first Surrealistic paintings in the middle of the 1920s. He later joined the group itself and followed their mission, 'to set up a meeting between an umbrella and a sewing machine on an operating table', in other words, to juxtapose incongruous elements and imagery, which he imbued with haunting significance. Early in life he had been a graphic artist, and this fact is reflected in his precise, flat, sharply delineated style. The paradoxical nature of reality and appearance provided the central conceit of his work.

André Breton's presence in Moderna Museet's Surrealist collection is palpable. Most of the works have at some time passed under his gaze; they have, so to speak, his blessing. This intellectual giant, poet, leading critic, owner of a remarkable art collection (it was from him that the museum bought de Chirico's famous *Brain of a Child*), author of the Surrealist Manifesto and organiser of the first exhibition of Surrealist objects in 1936, used Magritte's painting *The Red Model* on the cover of his book about Surrealist art.

The following is his comment on that work:

> Magritte, by caressing these things which belong to relative reality, if ever there was such, at the same time finds a way of releasing the latent energies smouldering within them. It is well known that he has at times allowed himself the luxury of performing before our eyes as he does in some of his most celebrated paintings – Le Modèle Rouge *(1936)*, L'Explication *(1951)* – not without the desirable dash of humour. Everywhere else the material elements, presented to the eye with the most scrupulous precision, shed their weight as they free themselves from the menial services that we expect of them. They behave as lures and decoys, and their whole function is to uncover what Magritte calls the 'visible poetic images'.

The following is Magritte's own 'explanation' of the work:

> The problem of the shoes demonstrates how far the most barbaric things can, through force of habit, come to be considered quite respectable. Thanks to Le Modèle Rouge, people can feel that the union of a human foot with a leather shoe is, in fact, a monstrous custom.

(Quoted from the exhibition catalogue *Magritte*, Hayward Gallery, London 1992)

Matisse, Henri
French
1869-1954

Paysage Marocain
Moroccan Landscape
1912

Oil on canvas
115 cm x 80 cm
Gift 1917 from Walter Halvorsen

From early in his career colour was of
prime importance to Matisse. Through
contact with the work of Gauguin, Van Gogh
and Cézanne, he began to develop a style
of his own. In 1905, along with Derain,
Vlaminck and others, he showed his works
at the Salon d'Automne in an exhibition
that gave rise to the term 'Fauvist' when
a critic called the paintings he saw there
'fauves' (wild beasts) due to their strong,
untamed colour. From 1916 Matisse spent
most of his life on the Riviera, first in Nice,
later in Vence. After 1941 his works became
increasingly abstract. His last years were
devoted almost entirely to his *découpages* –
non-representational abstracts – and to the
decoration of the chapel in Vence.

On 29 January 1912 Matisse arrived in Tangiers, putting up at the Hotel Villa de France. He had gone there to work but was prevented from doing so by incessant rain for several weeks. When the sun appeared again he started on a landscape, a representation of a private park belonging to a man named Jock Brook:

... it was immense, with meadows as far as the eye can see. I worked in a part which was planted with very large trees, whose foliage spread very high. The ground was covered with acanthus. I had never seen acanthus. I knew acanthus only from the drawings of Corinthian capitals that I had made at the Ecole des Beaux-Arts. I found the acanthus magnificent, much more interesting, green, than those at school! My spirit was exalted by these great trees, very tall, and below, the rich acanthus provided a no less important focus of interest through their sumptuousness...

I made a large canvas ... and when it didn't satisfy me, I decided that I would bring it back the following year. And to all those who saw the painting in Paris, I stopped them in their enthusiasm, telling them: 'It's not like that. It's better than that. You will see next year, when I will have reworked it.' I came back to Tangiers with my painting, and I put myself in front of the landscape with the idea of retouching my work. Everything seemed much smaller than when I had seenit the first time, and I told myself: 'What I thought I had left out in my painting turned out to be there well and good and not in the landscape after all!' So I came back without retouching the painting.

(Matisse in conversation in 1941 with Pierre Courthion, reproduced in *Matisse in Morocco*, Washington, 1990)

Matisse, Henri
French
1869-1954

Apollon
Apollo
1953

Gouache découpé
Collage on white painted
paper, mounted on canvas
327 cm x 423 cm
Purchased 1968 with
contributions from the
State, Moderna Museet's
Friends Association, Gerard
Bonnier and Carl-Bertel
Nathorst's Scientific and
Public Utility Foundation

After alternating for more than 50 years between drawing, painting and sculpture, in the early 1940s Matisse made his first *découpages*. Sheets of paper of manageable size were covered with gouache; these grew into heaps of warm and cold, deep and light shades of blue, yellow, red, orange and green. With a large pair of scissors Matisse then cut them into shapes: 'to cut straight into the colour is to me like when a sculptor chops straight into the wood'.

In the découpages I have found the simplest and most direct way of expressing myself. One has to study an object for a long time in order to find the sign for it. Each work of art consists of a collection of signs which come into existence during the course of the work simply because they happen to fit into the right place. There is no difference between my old paintings and the découpage, except perhaps that I have extracted the very essence of form through greater precision and greater abstraction. In the past I used to reproduce the object in its whole, now I only retain the most important bit – the signs of the object – so that it exists in its own form and as a part of the whole.

(Matisse, 'Témoignage', in *XXème siècle*, January 1952)

Apollon is made up of many signs and symbols: the sun god himself (the face, the sunrays, the glitter on the surface of the water) a heart shape for love, a tree trunk for a heart etc. It is as if Matisse had transcribed Ovid's story from *Metamorphoses*, in which Apollo, unhappily in love with the nymph Daphne, transforms her into a laurel tree.

Miró, Joan
Spanish
1893-1983

Tête de paysan catalan
Head of a Catalan Peasant
1925

Oil on canvas
145 cm x 114 cm
Gift through bequest 1989 from
Gerard Bonnier

Miró's early works combined subtle
references to Catalan folklore with a
Fauvist technique. In 1919 he visited Paris
where he became friendly with his fellow
countryman Picasso, whose Cubism was
to influence him for a while. After joining
the Surrealists he began to adopt his
characteristic style of angular, spiky forms
emerging from a smooth background
to create a dream-like effect, which he
incorporated into both figurative and
abstract paintings. In his later works
he eschewed the devices of Surrealism,
pursuing an individual expressive
abstraction.

In 1919, a year after he had painted *The Donkey in the Kitchen Garden*, (see page 27), Miró made his first journey to Paris. Over the next few years years he was to divide his time between Montroig in Catalonia and his Paris studio in rue Blomet.

Even when in Paris, however, he continued to paint the Catalan landscape from memory. But the process of remembering in order to pursue a dilligent, classical reproduction of reality, brought about a crisis: the more he was forced to imagine it, the more the smell of his native earth seemed to wane. Reality was becoming a convention, 'a poison' in Miró's own words. As a result he decided to change his approach.

Influenced by André Breton and the Surrealist poets he learnt to put himself in 'a sudden metaphysical state' and to substitute the wealth of detail in his work with greater simplicity and fewer forms. 'I agree with Breton that there is something very disturbing about a paper filled with text', wrote Miró in the summer of 1924. At the time he was busy with a painting of a farmer in Montroig, represented only by his cap – the characteristic Catalan 'barretina' – two circles for eyes and a moustache.

Back in Paris he made a third painting of the same subject, followed by this fourth version executed on a piece of newspaper (dated of 23 March 1925). Against a thin background wash (Miró called the blue 'the colour of my dreams') the farmer's head is suspended, as indicated by a black eye and the red cap – 'canvases which are simply drawn ... move one in a deeper sense ... in the more elevated meaning of the word, like when a little child is crying'.

(Quotes taken from Miró's letter 10 August 1924 to Michel Leiris, reproduced in Joan Miró's, *Selected Writings and Interviews*, 1986)

Mondrian, Piet
Dutch
1872-1944

Composition jaune et bleue
Yellow and Blue Composition
1933

Oil on canvas
41 cm x 32.5 cm
Gift 1989 from Gerard Bonnier

After studying at the Academy of Art in Amsterdam, Mondrian began his career painting at first subdued, realistic depictions of the Dutch landscape and then Symbolist works that strongly reflected his engagement with mysticism. Following his move to Paris in 1911, during the advent of Cubism, he began to peel away the details in these landscapes and still lifes, concentrating instead on reducing natural forms to horizontal and vertical lines. Seeking to move from Cubism into ascetic abstraction, he began to move towards 'the expression of pure plasticity'. In 1917 he founded the De Stijl Group together with Theo van Doesburg, restricting his palette to a few primary colours and banishing from his works all curved and slanting lines. Mondrian's last years were spent in New York where the influence of jazz introduced a restless rhythm and more playful use of colour to his works.

In 1934, Mondrian stated: 'What do I want to express in my work? Nothing different from any other artist: harmony through achieving a balance in the relationship between lines, colour and surfaces ...' But this simple declaration is belied by his slow transition from the tradition of landscape painting to the later abstractions and by the tortured process of finding the exact position of lines and balance of colours to achieve such harmony. The following extract gives an idea of the enormous demands he placed on the potentials of lines, colours and surfaces in his paintings:

The new art gives an independent existence to line and colour. No longer tyrannised or distorted by particular form, they establish their own limitations – limitations appropriate to their nature.

In the painting of the past, particular forms are generally confused or lost in the background of the picture. In the new art they are shown with increasing clarity on a plane that is no longer the naturalistic background of the past but the abstract representation of space. On this 'ground' the forms become determinate, distinctly separated, and display their inherent mutual relationships.

The mutual separation of particular forms is the beginning of the independent existence of line and colour. Precisely this separation brings to light the limited character of particular form and forces the search for neutral forms that transcend the limitations of particularity. These forms are created by another act of separation: the decomposition of particular form. Now the search for mutual equivalent relationships becomes essential. Finally, the decomposition of neutral form – complete separation – leads to the complete liberation of line and colour.

(Piet Mondrian, *Trois notes*, 1937, translated by J.J. Sweeney and published in *The Collected Writings of Piet Mondrian*, 1987)

Nilsson, Axel
Swedish
1889–1980

Right:
Vårbrytning
Springtide
1921

Oil on canvas
37.5 cm x 50 cm
Purchased 1991

Below:
Slokande hyacint
Drooping Hyacinth
(verso of Vårbrytning)
1921

Nilsson was a student at the Art Academy for just two years, abandoning his course along with Hilding Linnqvist, Fritiof Schüldt and Alf Munthe in the belief that it was too old-fashioned. As Linnqvist commented, Nilsson displayed a 'sublime indifference to finished and sellable items' and as a result very few of his early works – mainly watercolours – remain. From 1920-21 he lived in Sjövillan on Smedsudden where several of his most famous paintings were made. Following this he spent two years touring Italy. Over the course of his career he produced still lifes, interiors, portraits – including a number of self portraits – and landscapes.

In 1920 a group of painters, including Axel Nilsson, appropriated a deserted, empire-style house, the idyllic Sjövillan at Smedsudden, outside Stockholm. The 1812 house offered inspiration, peace, lodgings, and above all, lively discourse. Self-critical and slow-working, Nilsson found it 'easy to paint again' here. When autumn came and everyone else returned to the city, Nilsson stayed behind.

In the New Year he painted *Drooping Hyacinth*. The black scrawl beside the flower's stalk is a frame-maker's mark indicating that this is the reverse side of the panel. Several months later Nilsson was to paint a new work on the front side: the view from Sjövillan:

> *And then, some time in March, spring arrived – like a shot! We could be in the big room again, which was heated by the sun through the many windows. White seagulls glistened above the waters of the inlet again and the dormant desire to paint was awakened.*
> *The balcony doors were opened and that is how the 'famous' Vårbrytningen (Springtide) came into being. I painted it quite quickly. From the boat-yard nearby came voices and noise from hammers, the smell of tar. Boats were being done up in brilliant colours associated with the sea.*

(quoted from Axel Elwin, *Axel Nilsson*, 1970)

Oldenburg, Claes
American
b 1929

Right:
Pingpong Table
1964

Painted wood, plaster, cloth
97.5 cm x 135 cm x 210 cm
Purchased 1964

Below:
Sketch for 'Pingpong Table'
1963

Watercolour on newsprint
9.5 cm x 9.5 cm
Gift 1966 from the artist

Oldenburg graduated from Yale University in 1950. By 1956 he was making loosely brushed figurative paintings in New York. There, in 1960, in became involved with the happenings of Jim Dine and Allan Kaprow – interactive performances – which Oldenburg himself began to conduct. The crude costumes and props formed the basis for his later sculptures. Opening a small storefront shop, he sold painted plaster models of food and other objects. With these he created the basis for his characteristic tragi-comic statements on the cultural environment and became one of the initiators of Pop Art. His later works are soft, stitched-together everyday objects such as fans, typewriters and sauce bottles reversing expectations of hard sculpture.

In the series, The Home (1963-66) … 'doubles' is a common theme. You could say that a home would be unthinkable without 'the couple' and the 'pair' – after all, duplication is the function of mankind (coupling and motherhood). There is an element of mirroring in these works … each can be reduced to a simple shape or set of shapes. when the shapes are varied … the themes become apparent. For example …

1. Two round discs next to each other appear to be the ears of … Mickey Mouse …

5. If Mickey Mouse is divided into two vertically, and the parts are pushed together so that they partly overlap you get 'pingpong racket'. (The rackets also appear as double couples. The game is then called 'doubles') …

13. Pools, another work using doubles, parallels Pingpong Table. Originally Pingpong Table was to have been half a 'pool' table (as seen from the side). Pool is an American form of billiards, 'pocket billiards'. (Note: 'Pocket billiards' is also slang for a man scratching or playing with his 'balls' – genitals – through his pants' pocket.) One can buy tables in America that convert from the heavy (serious) table needed for pool to the flimsier (light-hearted, lyrical) pingpong table.

(From Claes Oldenburg's *Afterthoughts* published in *Konstrevy*, 5-6, 1966 on the occasion of the artist's exhibition at Moderna Museet)

1 5 13

Oppenheim, Meret
Swiss
1913-1985

Ma gouvernante - my nurse -
mein Kindermädchen
1936

Replica made by the artist
Painted shoes, string, paper
on metal dish
14 cm x 21 cm x 33 cm
Purchased 1967

Oppenheim was introduced to Surrealism
by Giacometti, and for a time was the model
and disciple of the photographer Man Ray.
The Paris Surrealists celebrated her as
the 'fairy woman' whom all men desire,
but around 1936 she became known as
an artist in her own right. She is best
known for her 'objects', often everyday
items such as utensils, given a bizarre,
sensual dimension by the use of such
materials as fur and leather. Her fur-
covered tea cup, and the work on the
opposite page, were both first exhibited
in 1936 and have become an iconic
symbol for the movement.

In May 1936 André Breton's *Exposition surrealiste d'objets* was held at Galerie Charles Ratton, 14 rue Marignan, Paris. The collection of 200 objects included items 'found in nature' (minerals and carnivorous plants); objects reinterpreted or 'disturbed' by events such as fire; Duchamp's readymades; sculptures by Picasso; Dali's liqueur glasses containing dead flies attached to a dinner jacket; primitive masks and fetishes; and *objets-trouvés* and *objets trouvés interpretés* (found objects and remodelled found objects).

Meret Oppenheim's contributed her famous coffee cup, saucer and spoon covered in fur. She also presented this work in which a pair of women's shoes are tied together and decorated with paper chef's hats like a roast chicken. The work bristles with connotations of bondage, fetishism and feminine sensuality. When the exhibition was over Oppenheim's work was vandalised by a woman 'out of jealousy'. The artist remade this work for her retrospective exhibition at Moderna Museet in 1967.

117

Picabia, Francis
French
1879-1953

Prenez garde à la peinture
Watch Out for the Painting
1919

Oil on canvas
91 x 73 cm
Purchased 1964

Picabia's early Impressionist works in
the style of Pissarro and Sisley earned
the young painter a considerable reputation.
From 1909 to 1911, he was a founder
member of the Section d'Or. In 1913
he went to to New York where he founded
American Dada with Duchamp. It was
there that he produced his post-Cubist
abstractions and began his mechanistic
fantasies and functionless machines. In
Paris some years later he took part in
provocative Dada demonstrations. After
the collapse of the Parisian Dada movement
he joined the Surrealists and continued
to show with them, though less actively,
throughout the 1930s. Also at this time
he produced his *Transparencies* – lyrical
collages on cellophane sheets with colour
wash. After a period during the Second
World War when he painted classical and
erotic nudes.

Though Picabia never dated his paintings, this work is thought to
have been executed in 1919 during his 'mechano-morphic' period
(1915-22). This was the year that year Dada came to Paris, finding
a headquarters in Picabia's home:

> *We paint without preoccupying ourselves with the
> representation of objects, and we write without looking
> out for the sense of words. We seek only the pleasure of
> expressing ourselves, but while doing so, giving to the
> diagrams we draw, to the words we align, a symbolic
> sense, a value of expression not only outside of all
> current convention, but by an unstable convention ...
> which lasts only for the very instant we use it. Also,
> the work finished, that convention lost from sight, it
> is unintelligible to me and besides no longer interests
> me, It is of the past.*

(Declaration by Francis Picabia in *L'Action Française*,
14 February 1920 – reproduced in *Picabia, Ecrits*, 1975)

But when Picabia showed this work in the Dadaist gallery *Sans
Pareil* in April 1920 the entire exhibition was ignored with 'a
delicate silence, the silence of sweet revenge' (George Ribemont-
Dessaignes) and practically nothing was sold.

Six years later the painting finally found a buyer in André Breton
who purchased it in an auction, organised by Duchamp, of 80
works by Picabia from the early Impressionistic landscapes to the
'monster pictures' of the latter years.

119

Picasso, Pablo
Spanish
1881–1973

Buste de femme
Bust of a Woman
1907

Oil on canvas
54 cm x 41 cm
Purchased 1964

Pablo Picasso dominated the development of modern art throughout the first part of the twentieth century. His precocious talent matured early. From 1900 to 1904 he alternated living between Barcelona and Paris, and his melancholy works of that time, known as his "blue" period, were related to Symbolism. In 1904 he moved permanently to Paris and the next few years – when his tone became lighter and his subject matter favoured harlequins, acrobats and dancers – are known as his "rose" period. From 1907 to 1909 he concentrated on the analysis and simplification of form, taking as his models the works of Cézanne and African sculpture, which eventually led to his invention (with Georges Braque) of Cubism. By 1917 Cubism had become an increasingly synthetic style, and Picasso embarked until the mid-1920s on a series of works which drew inspiration from classical and neo-classical art. From the late 1920s his work showed a preoccupation with cruelty, anguish and despair and had more in common with Surrealism. During the 1930s he concentrated on the recurring motifs of the artist and his model, the Minotaur, the Dying Horse and the Weeping Woman. After the Second World War he moved to the south of France, where his work remained as diverse and inventive as ever and embraced painting, sculpture, ceramics, linocuts and etchings.

Buste de Femme is possibly a study for *Les Demoiselles d'Avignon (1906-7)*, one of Picasso's most famous work and a precursor of Cubism. Daniel-Henri Kahnweiler, dealer and a great supporter of Picasso as well as other Cubist artists, describes its impact in his book *Den Weg zum Kubismus (The Road to Cubism)*, 1920:

> *This is the beginning of Cubism, the first upsurge, a desperate titanic clash with all of the problems at once. These problems were the basic tasks of painting: to represent three dimensions and colour on a flat surface, and to comprehend them in the unity of that surface. 'Representation', however, and 'comprehension' in the strictest and highest sense. Not the simulation of form by chiaroscuro, but the depiction of the three dimensional through drawing on a flat surface. No pleasant 'composition' but uncompromising, organically articulated structure. In addition, there was the problem of colour, and finally, the most difficult of all, that of the amalgamation, the reconciliation of the whole. Rashly, Picasso attacked all the problems at once. He place sharp-edged images on the canvas, heads and nudes mostly, in the brightest colours: yellows, red, blue and black. he applied the colours in thread-like fashion to serve as lines of direction, and to build up, in conjunction with drawing, the plastic effect. But after months of the most laborious searching, Picasso realised that complete solution of the problem did not lie in this direction …In the spring of 1908 he resumed his quest, this time solving one by one the problems that arose. He had to begin with the most important thing, and that seemed to be the explanation of form, the representation of the three-dimensional and its position in space on a two-dimensional surface. As Picasso himself once said, 'In a Raphael painting it is not possible to establish the distance from the tip of the nose to the mouth. I should like to paint pictures in which that would be possible.*

(Translated by Henry Aronson, *The Documents of Modern Art*, 1949.)

Picasso, Pablo
Spanish
1881-1973

Bouteille, verre et violon
Bottle, Glass and Violin
1912-13

Collage
Newspaper, wallpaper, charcoal,
pencil on paper
42 cm x 62 cm
Purchased 1967

In 1907, with *Bust of a Woman*, Picasso solved the problem of 'reproducing an object's volume and colour on a plane' by painting the subject against an 'almost monochrome' background and by using certain ideas he had borrowed from African and primitive Iberian art. The following year he began his fruitful dialogue with Braque – a dialogue that was to lead, a few years later, to the Cubist collages.

Between them Picasso and Braque re-orientated the depiction of volume in painting and restricted their use of colour to grey and ochre. By 1910 the closed form of the object was completely broken up into facets spread across the canvas. Of a violin, for example, all that remained was the sound hole, a few strings and the colour brown as a reminder of the wood. It seemed as if the object, the space and the background had merged. The paintings from 1911 became increasingly difficult to fathom. It was necessary to find a way back to reality.

Braque was the first to introduce letters and fragments of words into his paintings. Since a letter was already flat, it was not possible to distort it, and if the viewer could identify it, it would be easier to recognise the other forms.

Picasso and Braque spent the summer of 1912 together in Sorgues, near Avignon in Provence. At the beginning of September Picasso had to go to Paris to set up a new studio. In Avignon, Braque saw in a shop window a wallpaper roll whose pattern was an imitation of oak veneer. Before Picasso returned, Braque made two 'collages' in which this wallpaper appeared. (Some art historians claim that he had seen the wallpaper before Picasso had gone, but had said nothing until he was on his own.) Instead of painting wood or writing the word 'wood' it was enough to use a piece of imitation-wood paper to indicate it.

Picasso immediately accepted the challenge. With the new method, which they called *papier collé*, they had made a breakthrough: they could freely mix drawn, painted and 'real' objects, such as a piece of newspaper or fragments of a violin, in the same composition.

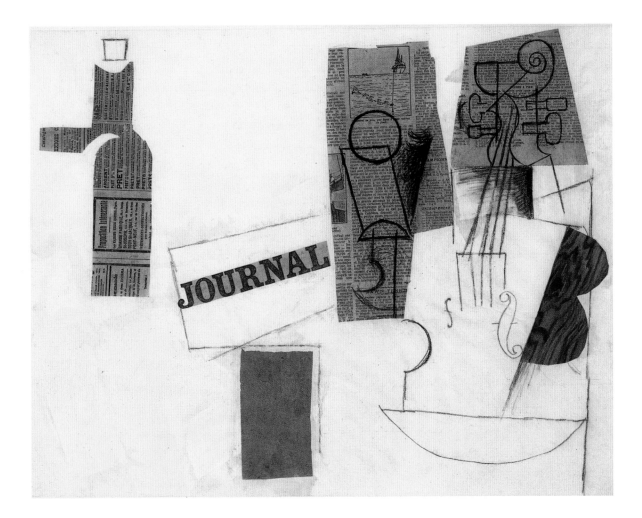

**Picasso, Pablo
Spanish
1881-1973**

Joueur de guitare
Guitar Player
1916

Oil and sand on canvas
130 cm x 97 cm
Gift 1950 from Rolf de Maré

Between 1913 and 1916, Picasso worked in a studio in rue Schoelcher, and it was here that he painted *Guitar Player*. The war had sent his friends to the front or into exile and the period of close collaboration with Braque was over. On his own, Picasso was to develop the potential of the collage. With the freedom to use fragments of real objects in the compositions came the freedom to explore different kinds of treatment of paint. In the collage the idea of the volume in a violin could be perceived, thus the flat piece of paper could also be seen as a real violin. Picasso thought equally flat surface forms of the painting ought to serve the same purpose idea. If different kinds of paper in the collage represented different kinds of material then different kinds of treatments of the paint could give as much life to the idea of reality.

In order to represent the dim light of the smoky night club in this work, Picasso mixed sand into the paint used for the black background causing it to shine and to assume substance. If he wanted to increase the sense of light, he could simply add white dots; if the whiteness was too sharp, he could stipple it with black. In contrast, the brown window is painted as thinly as silk.

The sharp edges of the white form with three grey lines give the impression that it is cut out of paper. At first sight it appears completely abstract, but it becomes apparent that it actually represents the guitar player's fingers on the strings. The distance between the hand and the head implies that he is standing up – perhaps rising from the cafe chair to receive applause.

Picasso applauded all artistic precision. He knew the laborious road there only too well.

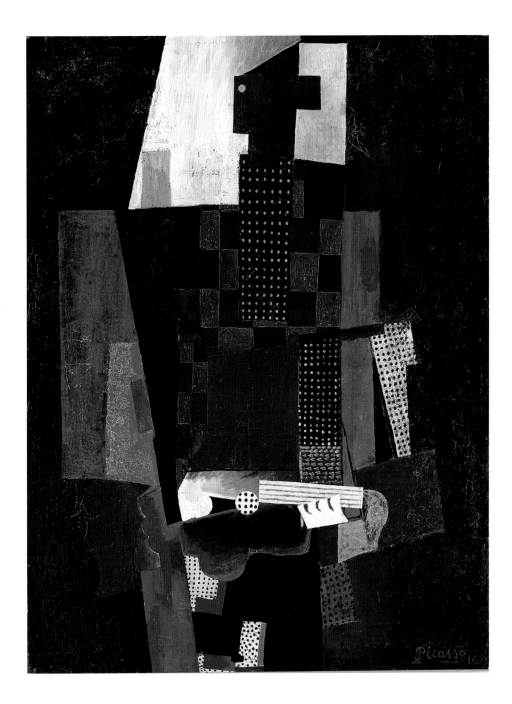

Picasso, Pablo
Spanish
1881-1973

La source
The Spring
1921

Oil on canvas
64 cm x 90 cm
Gift 1970 from Grace
and Philip Sandblom

When I have found something to express I have
disregarded the things I have done in the past or will be
doing in future. I don't think that the basic ingredients in
my different ways of painting vary so greatly from each
other. If the subject so demands I have never hesitated to
adapt my mode of expression to that. Different subjects
inevitably demand different modes of expression.

(From *Picasso Speaks*, conversations jotted down by
Marius Zaya 1923, published the same year in *The Arts*.)

Picasso's work was always rooted in what was in front of him.
In *Guitar Player*, no form was invented; every plane corresponded
to a real three-dimensional object. Cubism was a language among
other languages, and languages must be learnt. Picasso, who had
been told 'ad nauseam' that Cubism was incomprehensible,
commented: 'I don't read English, an English book is a blank book
to me. That doesn't mean that the English language does not exist,
and why should I blame anyone but myself if I can't understand
what I know nothing about.'

As a painter, Picasso was multilingual. His first language had been
that of academic Classicism, which he had mastered even as a
teenager, and at the outbreak of the war in August 1914 he started
to speak it again, albeit with a slightly Cubist accent. During the
years that followed he would continue to speak this and many
other languages.

Towards the end of the summer of 1916 Picasso accepted a
commission to make sets and costumes for the Russian Ballet's
production of *Parade*. Following the company's tours, he fell in love
with Olga Koklova, one of the dancers, who became the model for
The Source and other works. They married in July 1918.

Picasso, Pablo
Spanish
1881-1973

Le peintre
The Painter
1930

Oil on panel
50 cm x 65 cm
Gift through bequest 1989 from
Gerard Bonnier

Picasso preferred to paint in the afternoons or evenings – that is, in electric light – 'it is completely even and much more exciting'. He often worked on several canvases at the same time. After the painting was finished he was in the habit of sitting for an hour or so, evaluating the day's achievements. We know from Picasso's lover, Françoise Gilot, that he liked to have company in the studio during this time of reflection.

In *The Painter*, Picasso deals with a favourite theme: the painter and his model. The figure on the left is the model and the one on the right, sitting with one leg crossed over the other and with his head resting in his hand, is perhaps a representation of Picasso himself, who would often sit in this position. The large hand – with impatiently tapping fingers – can equally well be interpreted as his own. The flowing, organic forms of the figures owe a certain debt to the language of Surrealism.

129

Pollock, Jackson
American
1912–1956

Right:
The Wooden Horse
1948

Oil, duco, wood on canvas
90 cm x 178 cm
Purchased 1967

Below:
Pollock with The Wooden Horse

Pollock's early works alternated between two styles: one elegant and linear, the other rich and impasto. In 1947 he radically changed his methods, dispensing with conventional techniques, and instead, dripped and splashed the paint onto the canvas which was laid on the floor. These highly gestural works, or 'action paintings' as they were called, sometimes took on the nature of performance.

I don't work from drawings or colour sketches. My painting is direct ... The method of painting is the natural growth out of a need. I want to express my feelings rather than illustrate them. Technique is just a means of arriving at a statement. When I am painting I have a general notion as to what I am about, I can control the flow of paint: there is no accident, just as there is no beginning and no end.

(Statement by the artist in the film *Jackson Pollock*, 1951, made by Hans Namuth and Paul Falkenberg.)

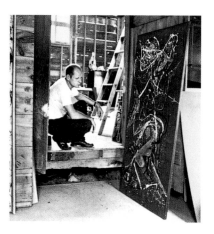

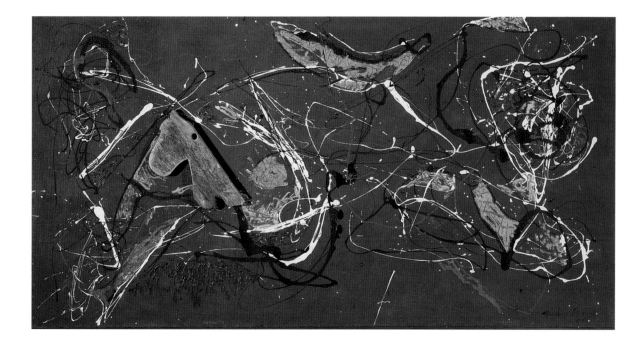

Rauschenberg, Robert
American
b 1925

Right:
Monogram
1955-59

Mixed media
122 cm x 183 cm x 183 cm
Purchased 1965 with
contribution from Moderna
Museet's Friends' Association

Opposite Below Right:
Monogram
3 sketches

Below Right:
Rauschenberg with Monogram in
his studio on Front Street, 1958
To his right is Bed and Odalisque

Rauschenberg studied at the experimental
Black Mountain College under Joseph Albers
and went back there to teach in 1952
mounting there one of the first happenings
with John Cage and others. A great admirer
of Kurt Schwitters he started to make
collages, assemblages and *combines* which
were free standing objects constructed out of
found or junk material and often incorporating
popular imagery into their surfaces. With
Jasper Johns, his close friend, Rauschenberg
anticipated the Pop Art of the 1960s but he
was always concerned to find new forms of
expression and in this respect has more in
common with Marcel Duchamp with whom
he shares a delight in word play, hidden
structures and multiple meanings. During
the 1960s Rauschenberg started to "collage"
silk screen blow-ups of photographs taken
from the popular press onto large canvases;
these reflect not only the imagery but also the
spirit of their time. In 1966 he started to work
actively on incorporating new technology into
his work and, with Billy Klüver, started the
EAT Foundation which stood for Experiments
in Art and Technology "to catalyze the
inevitable active involvement of industry,
technology in the arts." *Mud Muse* 1971, which
is also in the collection of Moderna Museet,
dates from this time of close co-operation.

First sketch c 1955
pencil on paper
30 cm x 22.2 cm
Collection of Jasper Johns

Second sketch c 1956
ball point pen on paper
7.6 cm x 12.7 cm
Collection of Jasper Johns

Second phase c 1956
292 cm x 81 cm x 112 cm

The materials in this work include an angora goat with painted nose and ears, a car tyre painted white, two canvases hinged together, painted and applied with collages of newspaper cuttings showing a tight-rope dancer and astronauts, a tennis ball, a plank, and fragments of letters that could spell out the word: DADA. The title, *Monogram*, might imply that this is Rauschenberg's self portrait.

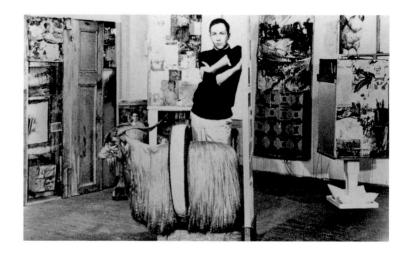

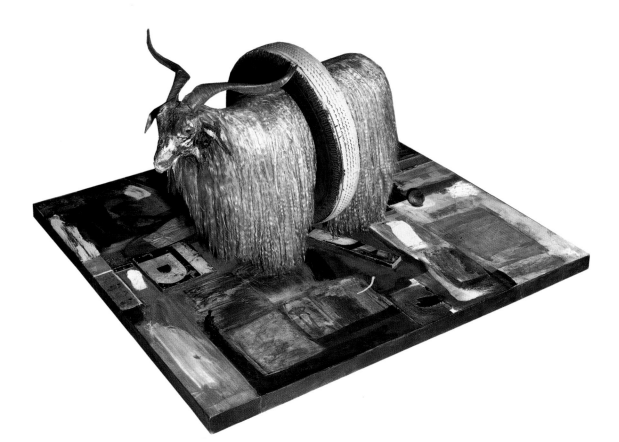

First sketch

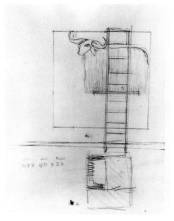

Second sketch

Second phase

Rodhe, Lennart
Swedish
b 1916

Skogen
The Forest
1977-79

Acrylic on canvas
12 canvases, each canvas
98 cm x 98 cm 294 cm x 392 cm
Purchased 1980

During his early period, influenced by Picasso, Rodhe made colourful Cubist works. In 1947 he began to produce completely abstract paintings, becoming one of the foremost representatives of the Swedish *Art Concrète* group. He sought to give expression to his concept of 'intangible space' by arranging angular forms in spiral formations. Later, he abandoned this geometrical approach in favour of a more spontaneous style, such as freely arranged areas of colour linked by interrelating lines and dots. He has also designed tapestry and stage sets, graphic works and lithographs.

A new motif, a plaited pattern, came to dominate Rodhe's work at the end of the 1970s and the beginning of the 1980s. As usual, the new work originated from a commission, this time a decorative textile for the auditorium in Kulturhuset, Stockholm. The idea was to create a pattern that could be repeated, as in wallpaper. The problem was getting the repeat patterns to seem natural and not mechanical: the drape had to work as one single picture not as a hundred repeated ones like a Warhol work.

What does the word 'mönster' ('pattern') mean? An etymological dictionary tells us that it comes from the French 'montrer', to show. (The same word root is found in words like 'demonstrate'...) Something showing itself. In that context the word can cover most of what Rodhe has done. For him it is not enough that a painting is seen: something must also be shown *in what appears – something that he had never foreseen, something extraordinary.*

One summer evening when he was working on The Forest *(the largest picture from the 'pattern period') he saw the light falling on the painting through the large studio window. He watched it a few evenings in succession and each time, he noticed something that he had never considered before: the light not only fell across the paint on the surface but also on the branches in the painter's imaginary room. Finally he painted the light exactly as it had fallen among the painted branches.*

(Ulf Linde in Moderna Museet's exhibition catalogue, *Lennart Rodhe*, 1988)

Rosenquist, James
American
b 1933

I Love You with My Ford
1961

Oil on canvas
210 cm x 237.5 cm
Purchased 1964

Born in North Dakota, USA, Rosenquist was once a billboard painter, the legacy of which can be seen in his graphic, large-format works, which utilise the techniques of advertising and the mass media such as the photographic close-up and the combination of fragmentary images. Other influences include Dalí, Magritte and fellow Pop artists Jasper Johns and Robert Rauschenberg. His iconography is also taken from contemporary culture: canned spaghetti, rubber tyres, atom-bomb clouds, car parts and light bulbs.

In 1960 and 1961 I painted the front of a 1950 Ford. I felt it was an anonymous image. I wasn't angry about that, and it wasn't a nostalgic image either. Just an image. I use images from old magazines – when I say old I mean 1945 to 1955 – a time we haven't started to ferret out as history yet. If it was the front end of a new car there would be people who would be passionate about it, and the front end of an old car might make some people nostalgic. The images are like no-images. There is a freedom there. If it were abstract, people might make it into something. If you paint Franco-American spaghetti, they won't make a crucifixion out of it, and also who could be nostalgic about canned spaghetti?

(From an interview with the artist in *Art News*, 1964.)

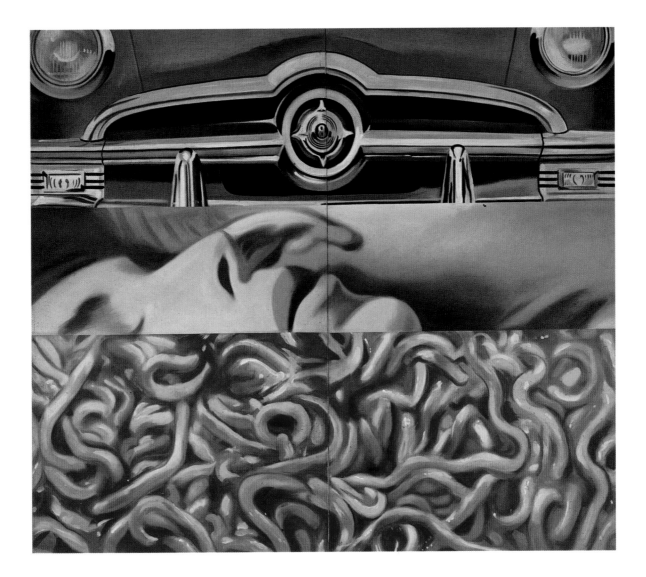

de Saint-Phalle, Niki
French
b 1930
and Tinguely, Jean
Swiss
b 1925-91

Le paradis fantastique
The Fantastic Paradise
1966

Monumental sculpture group
in 16 parts
Painted polyester/fibreglass
painted iron, motors
Gift 1971 from the artists

Niki de Saint-Phalle made her name in the
early 1960s with assemblages incorporating
small bags of paint, which she shot at with
a pistol, spattering pigment on a canvas.
These were followed by her first 'Nanas' –
huge, colourful, earth mothers made of
plastic. She met Tinguely at the beginning
of the 1960s, and they began a long-
standing collaboration. Their gigantic
'Nana' SHE, was exhibited at Moderna
Museet in 1966.

*Nine polystyrene sculptures covered with coloured polyester paint
by Niki de Saint-Phalle*
*Six machine sculptures made of iron, wood and motors by Jean
Tinguely. Made for the French Pavilion at the World Exhibition in
Montreal, 1967*

Paradise *was originally shown in Montreal, but it was later moved
to the Albright Knox Gallery in Buffalo, and then to Central Park
in New York where it was exhibited on a large lawn in a French-
Classical part of the park near 5thAvenue and 105th Street on
the border of Harlem. The sculptures were greatly appreciated by
the visitors in this part of the gigantic park... The small, sinewy
aggressive black sculptures that attack the flourishing 'Nanas'
were seen as a comment on the situation in New York. The park
authorities did not approve of this placing of* Paradise, *however.
Tinguely and Niki de Saint-Phalle decided in 1968 to give* Paradise
*to Stockholm, where, in a way, it had originated since it was an
offspring of* SHE. *Through a donation from Jean and Dominique
de Menil it became possible to transport it to Europe. The sculptures
were cut into smaller pieces and were shipped over, and after
extensive restoration work, which took over a year,* Paradise *was
unveiled in Stockholm in May 1971. Niki de Saint-Phalle had
repainted all the plastic sculptures and Tinguely had added a large
machine, made in Stockholm, a fountain that squirts water at two
Nanas who bathe in a large black basin.* Paradise *now stands on
Skeppsholmen in Stockholm harbour.*

(Pontus Hultén, *Jean Tinguely – Méta,* 1972.)

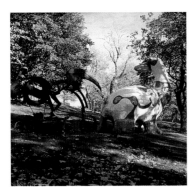 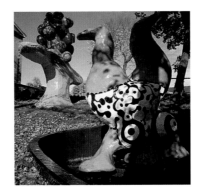 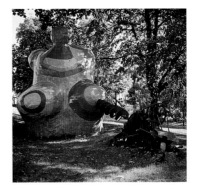

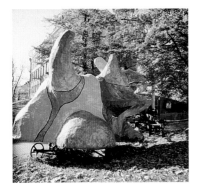 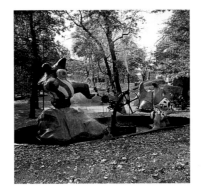 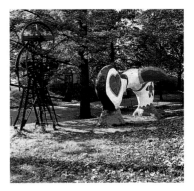

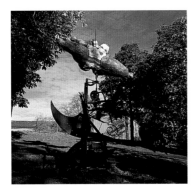

Sandberg, Ragnar
Swedish
1902-1972

Café Lilla Bommen
The Lilla Bommen Café
1938

Oil on canvas
73 cm x 90 cm
Gift 1994 from Peggy and
Pontus Bonnier

Sandberg was taught by Tor Bjurström at
Våland Art College in Gothenburg. Among
his fellow students was Ivan Ivarson. His
paintings from the early 1930s were of
the street life and cafes of Gothenburg,
often 'details, detached from the whole'.
He saw the big Bonnard retrospective in
Paris in 1937 and was impressed by this.
The strong colours that he used at this time
earned him the soubriquet of 'Gothenburg
colourist'. Towards the middle of the 1940s,
however, his palette became more subdued
and his compositions more geometric.
From 1947-58 he was Professor at the
Art Academy in Stockholm.

'How simple everything can appear at certain moments. Even the indefinable can assume a positive precision, put in its correct context', wrote Sandberg in his notes.

It takes time before one 'sees' his paintings. Their imagery lets itself be known gradually through the proportions of a form, the rhythm in a line or the placement of a colour. What at first appeared obscure begins to shine out in all its simplicity, like when an eye slowly regains sight and starts to orientate itself in a darkened room.

It is easy to see the ostensible subject of this painting – in a dark room a waitress awaits payment from three stevedores – but it is its otherness, its indefinable qualities that distinguish it. The detached right arm and wide sleeve of the woman, for example, hovering against the flat grey background; the way in which the raised arm of the man drinking from a bottle accentuates her slim waist; and the warmth of the day outside, seen through the window in the door.

Schwitters, Kurt
German
1887-1948

Das Arbeiterbild
The Worker Picture
1919

Oil, paper, cardboard, wood,
metal, cotton-wool on canvas
125 cm x 91 cm
Gift 1964 from Moderna
Museet's Friends' Association

Schwitters produced his first *Merzbilder* in 1918 and in the following year became a founder member of the Dadaist group in Hanover. *Merz* was a word he invented to describe the vast range of discarded words and items out of which he made his work. This could take the form of objects, pictures, poems, collages, constructions or structures. *Merz* was an all-encompassing term for everything the artist made and did. Schwitters constructed two vast *Merzbau* in Hanover which gradually took over his apartments and which provided an architectural context for his performances and smaller work. Branded as "degenerate" by the Nazis, he moved to Norway in 1937 and then escaped to England in 1940. During the war he was for a time interned as "an enemy alien" on the Isle of Man. When he was released he settled in Ambleside in the Lake District where he started to construct his last unfinished *Merzbau* in a barn.

The Merz *paintings are abstract works of art. The word* Merz *is really a compound of all the artists' materials that are used and, technically speaking, its meaning applies to each separate material. The* Merz *pictures are not only made from paint, canvas, brushes and a palette, but from all materials perceptible to the eye and all necessary tools. It is of indifference, in fact, if the materials used were meant for anything else or if they were not. The pram wheel, the hairnet, the string, and the padding are colours like any other colours. An artist creates by choosing, dividing and deforming his materials.*

The deformation can happen even when you are dividing up the materials on the surface of the picture. One can increase the effect by taking them apart, bending them, covering them or painting them. In the Merz *pictures the box lids, playing cards, newspaper cuttings become surfaces; strings, brushstrokes or pencil marks become lines, hairnets, extra washes or, stuck on greaseproof paper, a wash, the padding creates softness.*

Merz *pictures strive for immediate expression by diminishing the distance between the intuitive and visual appearance of the work of art. These words will make it easier to identify with my art for those who really want to understand me. Far too many will not want to. They will receive my new paintings the way they always have done when something new turns up: with anger and scorn.*

(Kurt Schwitters in *Das literarisches Werk*, vol 5, 1919.)

Segal, George
American
b 1924

The Dry Cleaning Store
1964

Painted plaster, wood, metal,
metal foil, neon
213 cm x 213 cm x 244 cm
Gift 1973 as part of the
New York Collection

Segal supported himself as a chicken
farmer until 1964 when he became a full-
time artist. He began as a figurative painter,
but in 1958 he started experimenting with
plaster sculptures, producing a life-sized
self portrait. These figurative sculptures,
which often reflect a sense of ruban
alienation, isolation and despair, have
continued to occupy him. Made by taking
a plaster cast from a live model, they are
placed in groups of one or more in specific
contexts, sometimes with a range of props
or in specially designed environments. His
use of popular, graphic imagery relates to
Pop Art but the mood of his work has more
in common with the urban paintings of
Edward Hopper.

I'm still not finished with that piece. That sign is a five-foot numeral one with a red outline, and the silver is there because that red neon changes it to pink and green. The neon light changes the blue metallic foil paper into a hundred shades of blue to purple to red, all in cubist crinkles. I've never since pursued the idea of being able to use light to fracture and disintegrate forms. I did The Dry Cleaning Store *at the same time I did* Cinema *and always thought that one was female and the other male.* Cinema *is single and unified, and* The Dry Cleaning Store *fractures and splinters into a thousand pieces. I still sense some connection.*

(George Segal in the exhibition catalogue *New York Collection*, Moderna Museet, 1973.)

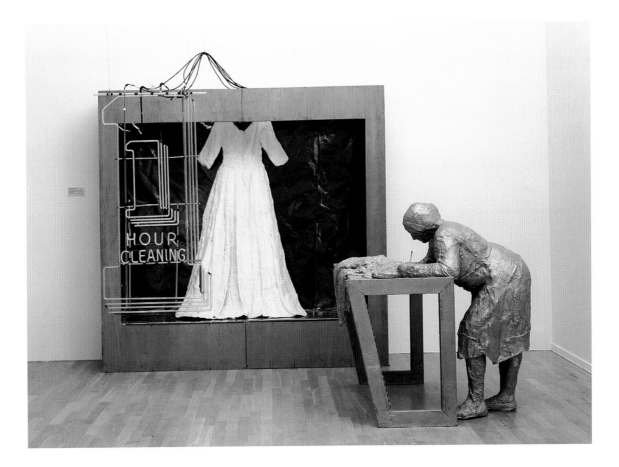

Sköld, Otte
Swedish
1894–1958

Hustak i Paris
Roofs in Paris
1921

Tempera on panel
48 cm x 110 cm
Purchased 1924

Born into a Swedish missionary family
in China, Sköld arrived in Sweden
in 1907. He later studied in Copenhagen. His
early work was Cubist with some Futurist
ambitions, but after having seen the work
of Derain in Paris he committed himself to
realism. He returned to Stockholm in 1927
where he opened his own art school,
worked on many public commissions, and
designed stage sets. In 1941 he became the
Director of Konsthögskolan, and from 1950,
the Director of the Nationalmuseum, a post
he held until 1958 when he realised a
long-term ambition – the creation of
Moderna Museet.

In Copenhagen, Otte Sköld developed his own mixture of Cubist forms and naturalistic detail, producing bold collages and sophisticated woodcuts. However, he was not content with this style:

I am still very uneven when it comes to methods. By which I mean that I waver from the strict style and pithiness of Cubism to a purely painterly aesthetic. But one day in the distant future I will be like my friends Luca Signorelli and Mantegna.

(Quoted in Rolf Söderberg, *Otte Sköld*, 1968.)

In the spring of 1920 Sköld moved to Paris and in the autumn of the same year, during a journey to Italy, he further acquainted himself with the work of these fifteenth-century artists:

At that time I reacted instinctively against accepted modern ways of painting and I only had one wish, to find the firm starting point from which I could move on in my artistic search, and for me that became the exact reproduction of nature, observing the conditions of painting, i.e. the mutual relationship between the colours, and the relationship of the paint to the form ... Grey, ochre, brown, in colder and warmer tones ... these subdued colours often yield as much colour as the stronger tones of red, orange, yellow, green, blue etc ...

(Quoted in Rolf Söderberg, *Otte Sköld*, 1968.)

While other exponents of the New Objectivity became Surrealists or began to practise non-figurative art, Otte Sköld remained true to these principles for the rest of his artistic life.

Strömholm, Christer
Swedish
b 1918

Den döda hunden
The Dead Dog
1958

Gelatin silverprint photograph
19.5 cm x 26 cm
Purchased 1982 with contributions
from The Fotografiska Museet's
Friends' Association

In his youth Strömholm studied painting,
but during the 1940s he became
increasingly interested in photography,
concentrating on subcultural groups such
as transvestites, whom he photographed
in Paris. At the beginning of the 1960s
he exhibited his collection of photographs
Poste Restante at the Gallery Observatorium
in Stockholm, simultaneously publishing
them in a book of the same title. At this
time he also founded Kursverksamheten's
School of Photography of which he was
Principal. In 1997 he was awarded the
Hasselblad Foundation Scholarship.

Strömholm learnt painting under Otto Sköld and Isaac Grünewald in the mid-1940s. Later he studied at the Art Academies in Paris and Florence, before taking up photography. During his training, his temporary jobs as tour leader, bar-tender and sailor brought him into contact with many unusual people, some of whom he photographed in controversial studies of alienation.

He produced his photographs rapidly, creating works that were often deeply moving. His pictures of boys, for example, display a deep identification with the vulnerability of childhood. The Kurverksamheten School, which he founded in Stockholm, was to be of enormous importance for future photographers in the 1960s. During the 1980s and '90s, his exhibitions have reached a large audience and he is one of the few Swedish photographers to have gained a strong reputation abroad.

Tinguely, Jean
Swiss
1925–1991

Right:
Méta-Matic no. 17
1959

Painted iron, paper, ink,
glass, motor, rubber
H 330 cm
Gift 1965 from Moderna
Museet's Friends' Association

Tinguely began making his mechanical constructions as a teenager with a water-wheel that simulated the sound of forest streams. His early works were abstract paintings and constructions of wire and metal. In 1954 he made a series of reliefs from layers of moving rods, which he called *Formes mouvementés*. These were followed by 'meta-mechanical' reliefs, motor-driven constructions, works incorporating rotating metal elements, and 'painting machines'. Tinguely has worked with the Moderna Museet on many occasions: for the 1961 exhibition at Moderna Museet, 'Movement in Art'; in 1966 to build the gigantic sculpture *SHE* with Niki de Saint Phalle and Per-Olof Ultvedt; in 1971 for the installation of *The Fantastic Paradise*; and in 1972 for a retrospective exhibition.

1. In October 1959, for the Young People's Biennale in Paris opened by André Malraux, Tinguely's motor-driven drawing machine, *Méta-Matic no. 17*, was installed in the space outside Musée d'Art Moderne.

2. *Méta-Matic no. 17* creates its graceful, free drawings.

3. While Méta-Matic no. 17 *walks about in an elegant and dignified manner, it produces a constant stream of drawings, which are cut off from the long paper-roll, one by one, by the blade of a knife. A light breeze wafts the drawings towards the spectators. The exhaust fumes from the small petrol-fuelled engine are captured in a balloon that slowly expands and can later be emptied outdoors. Those fumes that seep out are masked by lily-of-the-valley perfume sprinkled from a mechanism. The TOTAL ART has been achieved: sculpture, painting, rattling and ringing sounds, smells, movement, performance and ballet.*

(Pontus Hultén, *Jean Tinguely – Méta*, 1972.)

4. Tinguely loads a new roll of paper.

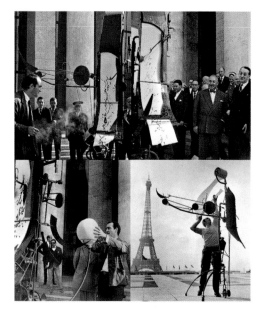

1 2
3 4

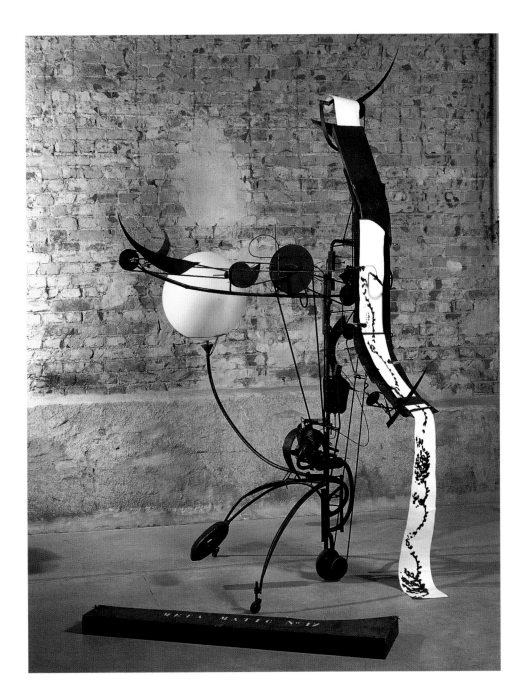

Ultvedt, Per-Olof
Swedish
b 1927

Flugsmällan
The Fly-Swatter
1962

Mobile sculpture
Wood, metal, plastic and motor
51 cm x 71 cm x 39 cm
Purchased 1982

As a young man Ultvedt produced paintings and graphic works featuring animal motifs. In the mid-1950s he began to make mobiles from welded metal and carved wood. Later, he incorporated articles of furniture and kitchen utensils into these and introduced mechanical movement. His rotating reliefs and black collages on white grounds set up dizzying optical illusions. The same kind of rhythm informs his black and white film *Nära ögat* (*A Close Shave*). In 1966 he collaborated with Jean Tinguely and Niki de Saint-Phalle on the monumental work *SHE*, becoming Professor at the Art Academy the following year. Today, he continues to make his ingenious works, which cause figures to move, dots to flicker and funeral drums to sound.

1954 Breaks his leg during a ski trip in the mountains. This immobilises him, causing him to reflect on movement – in art as well as life. Discovers he is technically gifted and, once recovered, starts to produce machines. Makes his first mechanical sculpture for the set of one of Lia Schubert's ballets, which was produced in Stockholm's Concert Hall in 1955. First contacts with Jean Tinguely. Sees exhibition Le movement *in Galerie Denise René in Paris. Collaborator in* Blandaren. *In a film called* En dag i staden (A day in town), *he is chased by police.*

1956 Makes Ikonoklasten, *a mechanical iron mobile.*

1957 Exhibits black and white collages and the film Nära ögat (A Close Shave), *which develops the painterly idea of collage, at Bokkonsum in Stockholm.*

1958 Finds a worn pig's trough in the countryside in Uppland and the idea for a certain type of wood relief is born. Makes the first 'household machine' in wood. Exhibits iron and wood reliefs at Bokkonsum.

1961 Is awarded K.A. Lind's big sculpture prize. Exhibits rotating reliefs and the household machine, Trä (Wood) *at Samlaren in Stockholm. The reliefs consist of two rotating discs, one in front of the other, on which have been painted straight or slightly curved lines. The front disc is equipped with holes. When the discs are set in motion – but in opposite directions – they create a soft, wave-like movement. Takes part in the exhibition* Bewogen Beweging (Movement in Art) *at the Stedelijk Museum in Amsterdam with a wooden machine that works like a kind of turnstile, which the visitors have to walk through. Makes a large, aggressive mobile in wood for* Rörelse i konsten, *at Moderna Museet plus a few mobile reliefs. Makes a mobile which brushes, scrapes and water for* Rörelse i konsten *in Louisana. Makes* Flugsmällan (The Fly-Swatter) – *a wooden box containing a flexible scrubbing brush, a comb and a fly-swatter, among other things.*

(from the artist's biography in the exhibition catalogue *Pentacle*, Paris, 1968.)

Viola, Bill
American
b 1951

I Do Not Know What
It Is I Am Like
1986

BETA SP PAL Archive copy single
screen videotape. Colour, Stereo
sound, 89 minutes. Filmed on 3/4
inch and 1/2 inch VHS transferred
to 1 inch master
Purchased 1988

Viola studied at the College of Visual
and Performing Arts in New York. In
1973 he and a group of musicians formed
Composers Inside Electronics Group.
During the years 1972-74 he worked
as an assistant to, among others, Peter
Campus, Frank Gilette and Nam June Paik.
In 1975 he became technical manager for
a production studio for artists in Florence.
Working for Sony Corporation in Japan
in 1980, he studied Calligraphy and Noh
theatre and practised Zen meditation,
disciplines that were to inform his work.
He received his first major one-man show
in Europe in 1983. Sculpting with light
and time, music and sound, Viola uses
advanced technology to create sophisticated
video installations, which he has called
'visual poems'.

In 1984 Viola travelled with his wife Kira Perov to the Fiji islands
filming different ceremonies and traditional events. This footage,
and film of zoos in San Diego, South Dakota, and the Rocky
Mountains in Canada were put together over two years for the
90-minute work *I Do Not Know What It Is I Am Like*. The title
is taken from *Rigveda*, one of the holy books of Hinduism dealing
with the subconscious, rebirth and eternal life. In this collage-like
work a cycle of rebirth is charted in five acts: *Il Corpo curo* (*The
Dark Body*) *The Language of the Birds*, *The Night of Sense*,
Stunned by the Drum and *The Living Flame*. His longest work
at that time, it makes reference to elements of his older works,
placing them in a new context.

Warhol, Andy
American
1928-1987

Chelsea Girls
1966

16mm, colour and black & white,
optical sound, 24 frames per
second, Split screen projection
195 min
Purchased 1968

Beginning his career in advertising, Warhol
made paintings, sculptures and silk-
screens using the imagery of American
popular culture. This ranged from soup
tins, dollar bills and washing powder to
film icons, car crashes and the electric
chair. Calling his fashionable gallery/studio
The Factory, he aimed to demystify major
themes such as fame and death through
the mass-production of objects. He also
made numerous films and was the
manager of the cult rock band, the *Velvet
Underground*. A consummate self-publicist
he cultivated a enigmatic image and his
influence on subsequent generations is
still palpable.

*What we could offer – I mean from the beginning – was
newer and freer content, and a way of looking at real
people and, even if our films were not particularly
technically polished, the underground movement was,
right up till 1967, one of the few places where people
could hear about forbidden subjects and see realistic
scenes from contemporary life.*

(Andy Warhol, *POPism*, p. 280.)

A commercial success, *Chelsea Girls* exposed Andy Warhol to a
larger audience than ever before. As in his earlier films, he lays
bare his cast of gay and transvestite actors in scenes that range
from the slow pace of real time to the extremely lively. Warhol
often filmed as if through a keyhole, placing the camera on one
spot in the room where it registered everything within its field of
vision. During the first three years in which he worked with film
(1963-66) he let the camera run continuously as an ongoing
document, only breaking when the camera needed to be reloaded.
One can view *Chelsea Girls* as a combination of documentary and
psychological drama where the actors often seem oblivious to the
camera. Occasionally, however, they ask Warhol to stop filming.
For two of the 12 scenes, a script by Ronald Tavel was used but
watching these people carrying out their everyday tasks one
hardly notices, except in Ondine's long, manic monologue.
The double-screen projection meant that the same actor could
perform in two contrasting scenes simultaneously. For instance,
Mary Might plays a dominant lesbian exhibitionist on one screen,
and the defender of a shy girl on the other. With this device,
Warhol increases psychological tension and also introduces an
element of absurd humour.

Warhol, Andy
American
1928-1987

Marilyn Monroe in
Black and White
1962

Oil on canvas
208 cm x 140 cm
Purchased 1965

In August 1962 Warhol made his first photo-silk-screen works. The technique of printing, he maintained, was just as authentic as painting by hand and it also raised the rate of production. And the work could be carried out by others. The more often the screen was used, the dirtier – more painterly – it became; a clean screen gave a more distinct image.

The work was made on the studio floor. First the background was painted and then the motif was screened on. It was only afterwards that the canvases were stretched.

That summer the news had come of Marilyn Monroe's death. A flood of photographs of the celebrity washed over America. The tragic image of the beauty who had chosen death was circulated in millions of editions. Warhol's *Marilyn* came from a still from the film *Niagara*, 1953, already an archetypal image. It was frequently reproduced by Warhol in the following years, but this version is one of the first.

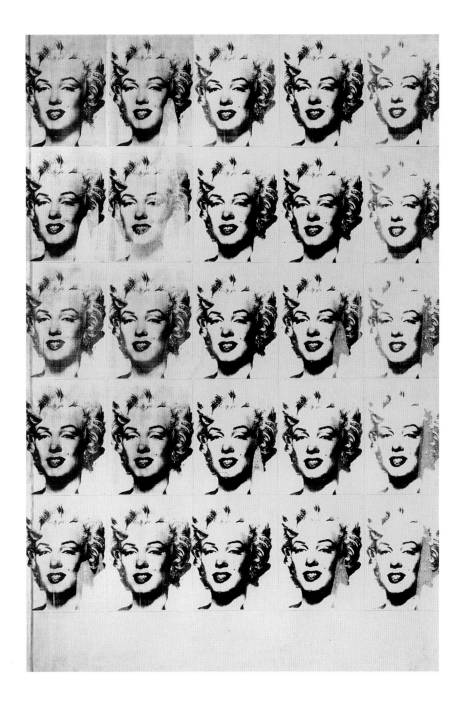

159